LITTLE BOOK OF

VALENTINO

Karen Homer is a fashion journalist and bestselling author. She has worked as a columnist for *The Times* and contributed to the *Telegraph, Harpers & Queen, Elle, World of Interiors* and *Vogue*. Homer is the author of *Little Book of Dior, Little Book of Gucci* and *Things a Woman Should Know About Style*. She lives in London.

Published by in 2022 by Welbeck
An imprint of Welbeck Non-Fiction Limited
part of Welbeck Publishing Group
Offices in: London – 20 Mortimer Street, London W1T 3JW &
Sydney – 205 Commonwealth Street, Surry Hills 2010
www.welbeckpublishing.com

Text © Karen Homer 2022
Design and layout © Welbeck Non-Fiction Limited 2022

A CIP catalogue record for this book is available from the British Library.

ISBN 978-1-80279-014-6

Printed in China

10 9 8 7 6

LITTLE BOOK OF

VALENTINO

The story of the iconic fashion house

KAREN HOMER

WELBECK

CONTENTS

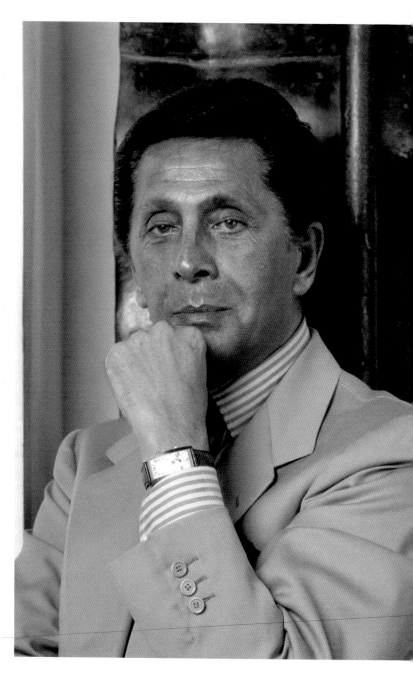

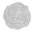

INTRODUCTION

"I know what women want. They want to be beautiful."

VALENTINO GARAVANI

There are few designers more synonymous with glamour than Valentino Garavani. Known simply by his first name, the Italian designer is the celebrity's favourite when it comes to Oscar gowns in "Valentino Red" or society wedding dresses in exquisite concoctions of lace and organza. He has enjoyed great success in the world of fashion, both critically and commercially, over a period of almost 50 years.

Named after the screen idol Rudolph Valentino, he was a child obsessed by the sirens of the golden age of cinema, so it is fitting that once Valentino opened his own atelier in Rome in 1959, his first big client was Elizabeth Taylor. His clientele soon grew to include other famous actresses and socialites, most notably the style icon Jackie Kennedy.

Valentino not only created wonderful clothes for these famous and beautiful women, but he also developed lifelong close friendships with many of them. Along with his partner

OPPOSITE Valentino Clemente Ludovico Garavani.

OPPOSITE In 1967, Valentino opened a new, grander atelier on Via Gregoriana, where he moved all his business and design operations. He is pictured here shortly after the move, surrounded by models wearing his fabulous printed gowns.

Giancarlo Giammetti, he quickly became a celebrity in his own right and cemented his status as one of the world's leading haute couture designers by delivering the elegant, tailored daywear and stunning, embellished evening gowns so beloved by his high-society clients.

During the 1970s, Valentino was taken under the wing of th legendary *Vogue* editor Diana Vreeland, and spent a considerable amount of time in New York, becoming part of the fashionable Studio 54 crowd alongside iconic names such as Andy Warhol, who later produced a series of screen prints of the designer. The following two decades saw a return to Rome, where Valentino produced biannual haute couture and ready-to-wear collections, managing to successfully navigate the fine line between his classic silhouette and the trends of the day, even when he confessed to hating the 1980s silhouette.

Despite some financial wobbles around the turn of the millennium, when the Valentino label was sold twice within a period of five years, Valentino himself continued to remain actively involved in the company until his retirement in 2008. In tribute, several retrospectives of his work were held along with the screening of a behind-the-scenes film, *Valentino: The Last Emperor*. All served to underline Valentino's huge achievements and importance within the world of fashion design.

After his retirement, the creative direction of Valentino was taken in hand by the designers Maria Grazia Chiuri and Pierpaolo Piccioli. Under their stewardship, the label has flourished in a modern era, appealing to a new raft of young celebrity clients while still retaining the heritage of Valentino and his old-school glamour. It may not look quite the same, but today's red-carpet gown is as likely to bear the label Valentino as ever.

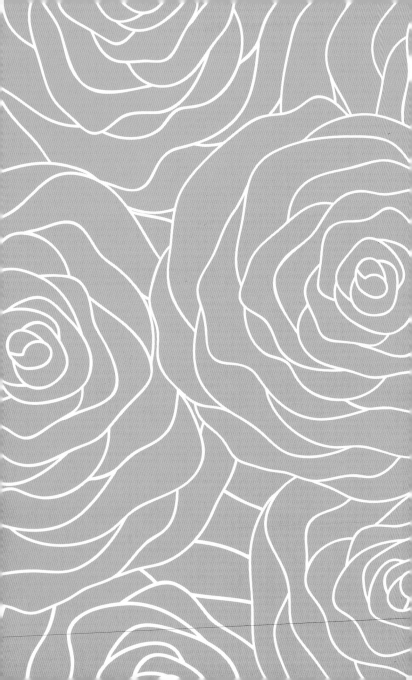

EARLY YEARS

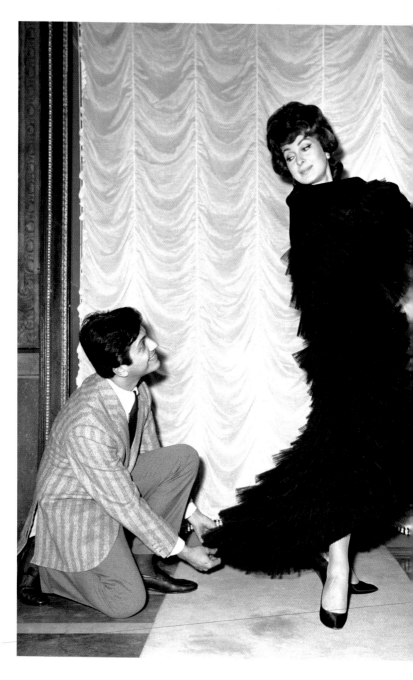

GLAMOROUS BEGINNINGS

Valentino Clemente Ludovico Garavani was born on 11 May 1932, in the small town of Voghera in the Lombardy region of Italy. As a child, he was transfixed by actresses such as Lana Turner, Hedy Lamarr and Judy Garland. In an interview for *System* magazine by Hans Ulrich Obrist in 2015, Valentino remembered visiting the cinema, aged just seven, with his older sister, to be captivated by "beautiful films with beautiful stars wearing beautiful dresses; for me at that time, they were like a dream"

This early passion for the cinema would remain central to Valentino throughout his career, not only as a source of design inspiration but also as a world where he found many of his muses. The love affair with performance continued even after his retirement in 2008: he went on to create costumes for the Paris Opera Ballet and the New York City Ballet. In 2016, along with his successors at Valentino, Maria Grazia Chiuri and Pierpaolo Piccioli, he created the costumes for Sofia Coppola's production of *La Traviata*.

OPPOSITE Valentino was devoted to Rome's glamorous Italian actresses from the very beginning of his career. Here he adjusts the hem of one of his dresses, worn by Silvana Pampanini in 1956.

ABOVE Valentino Clemente Ludovico Garavani was born on 11 May, 1932 in Voghera, a small town in the Lombardy region of Italy, pictured here in 2020.

As a child and young adult, Valentino was particularly captivated by the glamour of evening dresses, which he spent many hours sketching, an interest which anticipated his future success. He explained to Obrist: "My cousins used to dress very, very well, and every time they wore an evening gown, I was there staring at them."

Inspired to be a fashion designer for as long as he could remember, Valentino was as passionate about art as he was

about dresses, and he moved to Milan in 1949 to study fashion illustration at the Santa Maria Institute. Aware that to become a serious designer he would need to study in Paris, he also took a course to learn French before moving there, where he studied at the École des Beaux-Arts and the École de Chambre Syndicale de la Couture Parisienne. Valentino was immediately captivated by the French haute couture houses that represented the pinnacle of the fashion industry. The culture of fashion

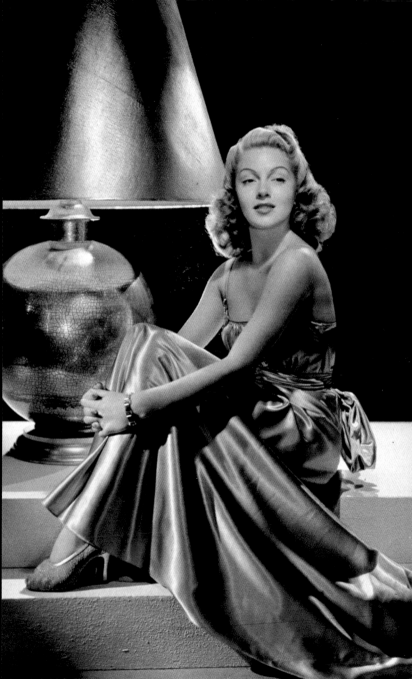

OPPOSITE A still from
the 1940 musical *Two
Girls on Broadway*,
starring Lana Turner.
The wonderful
dresses worn by
silver-screen stars
were an inspiration to
Valentino, who began
visiting the cinema
with his older sister
when he was just
seven years old.

RIGHT Judy Garland
also captivated the
young Valentino, who
later recalled these
screen images as being
"like a dream".

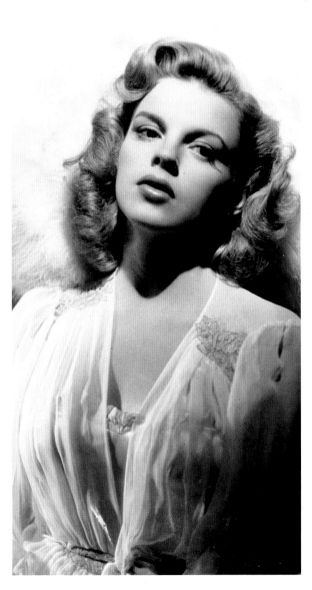

design at the time was extremely elitist, and most foreign designers, and in particular Italians, were looked down on as inferior. Nevertheless, Valentino was determined to succeed, soon proving his talent by winning the 1950 annual fashion prize sponsored by the International Wool Secretariat. His name is one of the first recorded by the textile institution, which subsequently awarded prizes to many of the most famous designers of the twentieth century, including Yves Saint Laurent, Karl Lagerfeld, Giorgio Armani and Ralph Lauren.

As a result of the prestigious prize, Valentino took up several apprenticeships with esteemed designers, including Jacques Fath and Balenciaga, as well as the society couturier Jean Dessès. At Dessès he spent five years learning the art of elaborate evening wear. He worked alongside an illustrator by the name of Guy Laroche, and in 1957, Laroche set up his own label, taking Valentino with him. For the next two years, Valentino learned how to manage the day-to-day running of a burgeoning fashion house. He told the curator, fashion historian and author Pamela Golbin: "I dealt with everything and learnt more and more. I handled all sorts of things – drawings, dressing the models for the runway, and getting into taxis to go and pick up dresses."

The experience was extremely valuable and gave Valentino the confidence to fulfil his dream: returning to Rome and opening his own atelier on the famous Via Condotti.

OPPOSITE Couturier Jean Dessès, with whom Valentino apprenticed and who first introduced him the world of designing for celebrity clients.

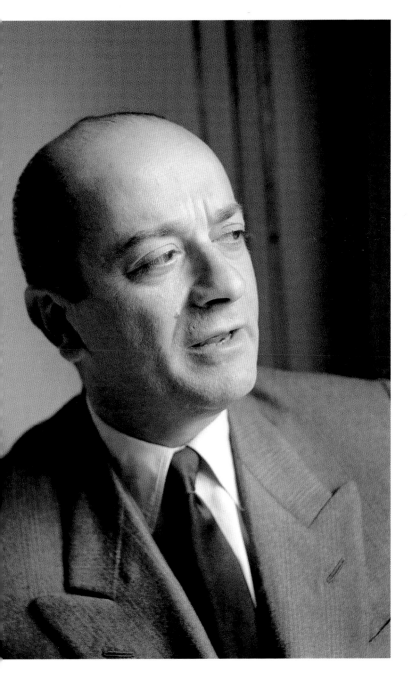

ATELIER VALENTINO

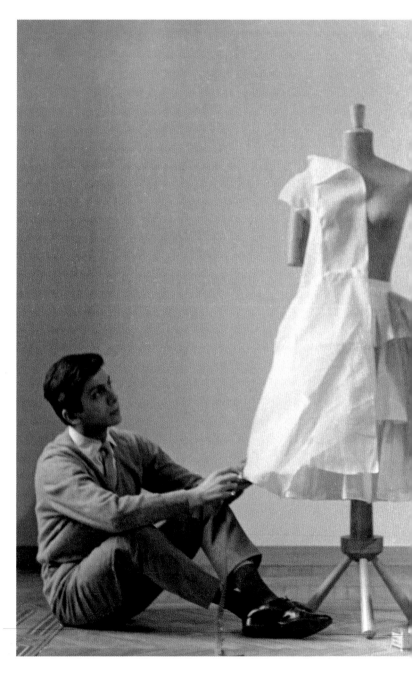

A DREAM REALIZED

"I believe only in high fashion. I think a couturier must establish his style and stick to it. The mistake of many couturiers is that they try to change their line every collection. I change a little each time, but never too much, so as not to lose my identity."

VALENTINO GARAVANI, **Women's Wear Daily,** *1968*

In 1959, Valentino left Paris with the promise of financial backing from his father and his father's business partner to start his own label in his beloved Italy. Enthralled by the world of haute couture, he opened his fashion house in Rome at 11 Via Condotti, modelling it on the ateliers and salons he had so admired in Paris. Valentino had honed his design style too, absorbing both the technical expertise and structural formality that reigned at Dessès, and the more modern, colour-saturated designs favoured by Guy Laroche.

OPPOSITE Valentino attends to a mannequin at his Rome atelier in 1959, having finally realized his dream of opening his own fashion house.

His first collection was entitled "Ibis", and while the press gave it a good review, noting the influence of his Parisian internships, Valentino later admitted to Eugenia Sheppard that it was "full of ideas, but had no personality". However, looking back on the collection – which included "Fiesta", an elegant strapless cocktail dress of draped tulle, and the first to appear in the bold and now famous colour that became known as Valentino Red – it is easy to see his charismatic personality shining through. The 1959 dress has become a vintage icon and was worn again by Jennifer Aniston to the premiere of the film *Along Came Polly* in 2004.

Despite his misgivings about his debut collection, Valentino was determined to find his fashion voice and continued to pursue his dream of becoming a famous couturier. The following

BELOW Fashion buyers and press gave Valentino's debut collection positive reviews, although the designer himself later complained that it had "no personality".

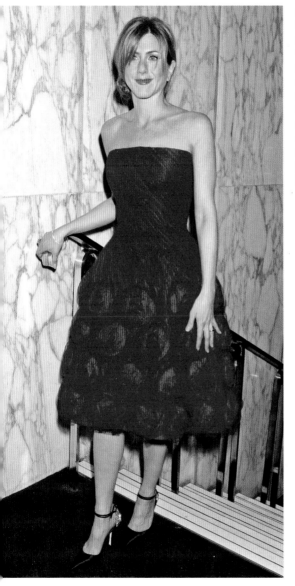

LEFT The first of Valentino's iconic red dresses was the "Fiesta" strapless cocktail dress with roses, from his debut collection in 1959. In 2004, over four decades later, it was worn by Jennifer Aniston to the premiere of *Along Came Polly*.

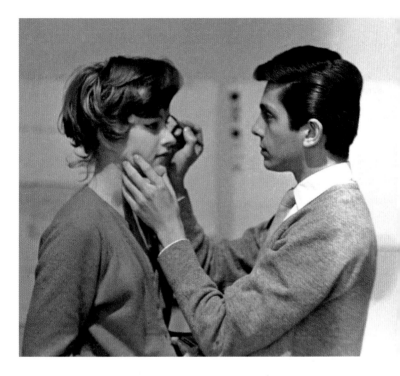

year, a serendipitous meeting with a young architecture student named Giancarlo Giammetti changed everything. Giammetti would become Valentino's partner for life, in both a personal and business capacity. For 12 years, they were romantically involved and later, the pair formed an inseparable bond. In a 2013 interview with *Vanity Fair*, which described the two as "blood brothers", Giammetti explained: "I was just 30 when the physical part of our relationship ended, and it was difficult in the beginning. We had to solve problems with jealousy."

Nevertheless, the love and respect the pair have for each other endures to this day. In 2011, Giammetti told the *Independent* that theirs is "a fraternal love…a relationship with nothing sexual

ABOVE A perfectionist, Valentino was as skilled with make-up as he was with fashion design, and in the early days could be found perfecting models' looks before a show.

it. Yet a great love remains, ancient, surviving." Valentino also admitted that he and Giammetti were too different to survive as a romantic pairing: "Giancarlo and I understand each other, but his character is the opposite of mine."

Despite their somewhat unorthodox relationship, Giammetti has been intrinsic to the success of Valentino S.p.A. since the very beginning when the fledgling business faced ruin after Valentino's father's business partner withdrew his financial support. Giammetti abandoned his architecture training to work alongside Valentino and the two men moved the salon and atelier from Via Condotti to Via Gregoriana. Their new premises, where they occupied a spacious apartment on the first floor, soon started attracting the glamorous clients for which the house of Valentino would become known.

Italy in the early 1960s was the perfect setting for a designer whose early inspiration came from the glamour of the silver screen. Rome was the home of Cinecittà, roughly translated as

BELOW Rome's Cinecittà studios were the largest in Italy and from 1950 to the early 1970s hosted many famous films. Valentino gleaned great inspiration from the buzz around the studios and its glamorous actresses, especially Italian stars like Sophia Loren and Gina Lollobrigida, pictured here greeting the designer in 1970.

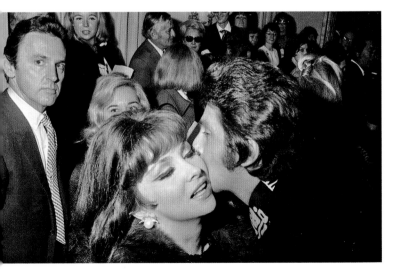

"Cinema City", with its stars including Gina Lollobrigida and Sophia Loren. Directors such as Visconti and Antonioni were taking full advantage of the city's romantic aspect in their films, especially after the success of Federico Fellini's *La Dolce Vita,* released in 1960. That same year, Elizabeth Taylor attended the premiere in Rome of Kubrick's *Spartacus* and was one of the first celebrities to visit Valentino's salon, buying a gown for the occasion and immediately sealing his reputation. It was the start of a long patronage and also a deep friendship.

In 1962, Valentino joined what was known as the Sala Bianca group of couturiers, an initiative set up by Count Giovanni Giorgini in 1951 to give credibility to young Italian fashion designers. From 1952, Giorgini arranged for this early group of just 15 designers to show their collections at the Sala Bianca in the Pitti Palace in Florence a week before the Paris collections to tempt buyers, a tactic that worked remarkably well. As a newcomer, Valentino was given one of the less coveted slots on the final day of the show – but his show was a hit, particularly among the American buyers, and it announced Valentino as a serious player in the world of fashion design. The fashion press took notice too, with a design from the collection featured on the cover of French *Vogue* – an unheard-of accolade for any foreign designer, let alone an Italian one.

The popularity of Valentino's designs among the American fashion buyers marked the beginning of financial profitability for the design house. The cost of producing clothes in Italy was low in comparison to France or America, allowing Valentino to supply department stores and boutiques at extremely reasonable prices. His cachet among American socialites also grew, with relationships forged with the likes of Gloria Guinness, Jackie Kennedy and her younger sister Lee Radziwill, and Nan Kempner. In 2006–07, when the Metropolitan Museum of Art staged a celebration of Kempner's

RIGHT Elizabeth Taylor with Kirk Douglas at the party in Rome for the film *Spartacus*. The actress is wearing a long, pleated, sleeveless Valentino gown with a decadent feathered detail at the bottom.

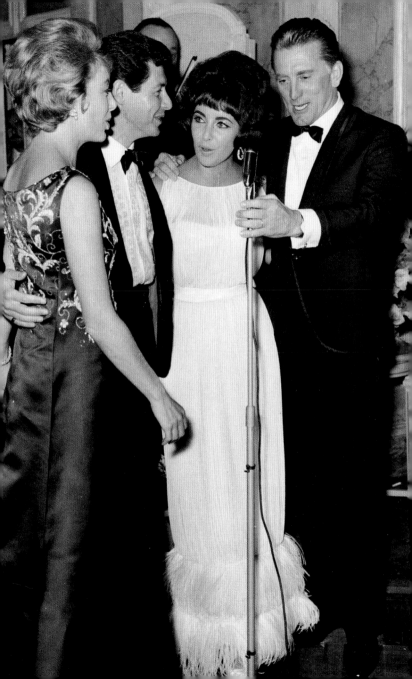

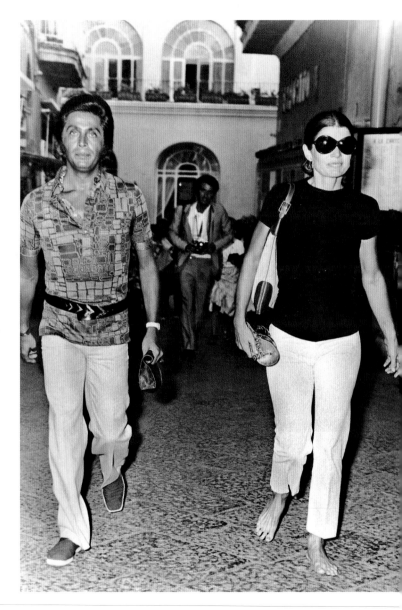

OPPOSITE Jackie
Kennedy Onassis
contributed hugely
to Valentino's early
success. The pair
are pictured here
in Capri in 1970,
the style icon
wearing her beloved
combination of black
and white, which so
inspired Valentino's
monochrome
palette.

OVERLEAF
Marisa Berenson
photographed at Cy
Twombly's Roman
palazzo for *Vogue* in
March 1968 wearing
an outfit from
Valentino's famous
White Collection.

style, Valentino explained: "Nan always looks so wonderful in my clothes, because she had a body like a hanger."

The relationship with Jackie Kennedy was extremely rewarding for Valentino, who started dressing the widowed first lady in 1964. She was one of the most photographed and stylish women of her generation, so her endorsement guaranteed success. In 2007, he told *Vogue*: "I owe so much to Jacqueline Kennedy. Meeting her meant so much to me. She became a very close friend. I designed her entire wardrobe, and she made me famous."

With his new fame came many more orders and increased financial security that allowed Valentino to expand. He opened a salon in Milan, which gave him the confidence to leave the Sala Bianca group and present new collections in his own Roman salon on Via Gregoriana. Seemingly unstoppable, Valentino received the Neiman Marcus Award, a prestigious American fashion prize, in 1967, and shortly afterwards he moved his salon further down the same street to a magnificent eighteenth-century palazzo.

Valentino's designs impressed throughout the mid 1960s as he experimented with a monochrome palette inspired by the black and white wardrobe commissioned by Jackie Kennedy. In 1967, Valentino was again inspired by Jackie Kennedy to make a collection of 12 white dresses, which provided the springboard for his legendary Collezione Bianca, or White Collection, which he presented for Spring/Summer 1968. The collection was extremely accomplished, exhibiting skilful flourishes in both structure and embellishment, and the fashion press went wild. *Vogue* enthused over "his crisp whites, his lacy whites, his soft and creamy whites, all shown together white on white".

The collection went down in history: Pierpaolo Piccioli, the current Valentino creative director, presented an homage in the

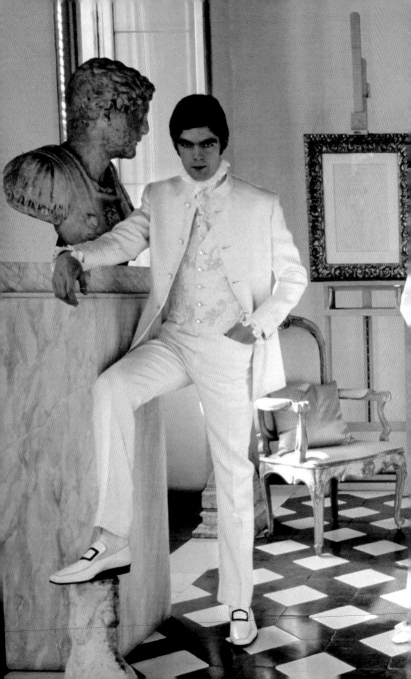

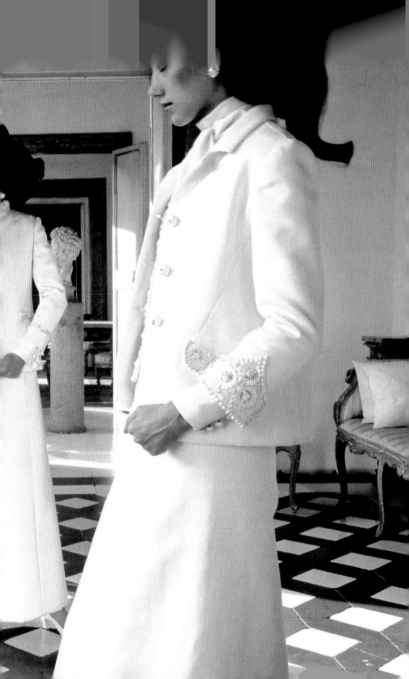

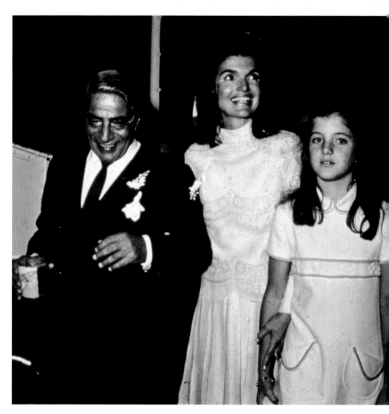

form of 12 white dresses for his Spring/Summer 2020 show. Perhaps the icing on the cake for Valentino himself was Jackie Kennedy choosing one of the dresses from the collection to wear for her second wedding, to Greek shipping magnate Aristotle Onassis, on 20 October 1968.

With his place among the top couturiers in the world confirmed, Valentino returned to open a boutique in Paris in May 1968, a decade after he had left. Finally, he was back in the rarefied world of French haute couture as a designer worthy of their respect.

ABOVE Jackie Kennedy Onassis pictured wearing a Valentino gown for her 1968 wedding to shipping magnate Aristotle Onassis. The couple are accompanied by 10-year-old Caroline Kennedy.

BELOW Valentino's Paris boutique proved immensely popular. Here, the designer helps Countess Maria Elena di Ravasenda with her many purchases.

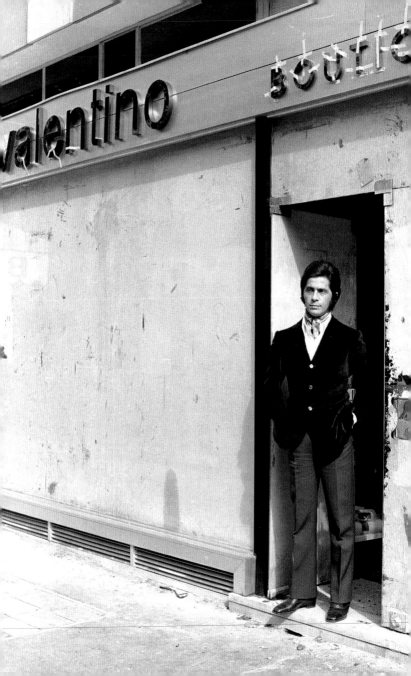

RIGHT By the end of the 1960s, Valentino's trademark glamorous style was firmly established. In 1967, Marisa Berenson modeled a vibrant fuchsia pink Valentino gown for *Vogue*.

OPPOSITE Valentino standing in the doorway of his first Paris boutique, which opened in 1968.

OPPOSITE In a 1967 shoot for *Vogue*, model Benedetta Barzini epitomizes Valentino's ostentatious Italian style in a red wool and lurex brocade evening dress against a backdrop of the Benedictine cloister in Monreale, Sicily.

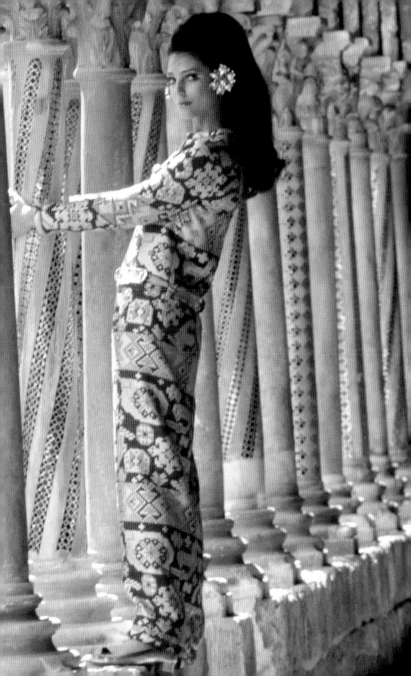

CELEBRITIES
AND
SOCIALITES

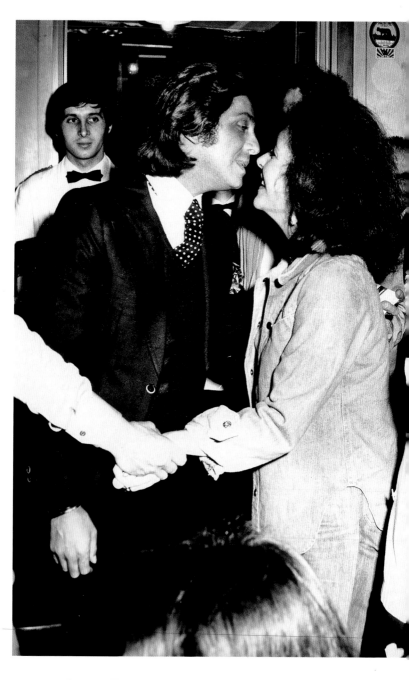

MUSES AND FRIENDS

Valentino has spent his career dressing the most glamorous women in the world, becoming many a celebrity's first choice of designer. He has also formed close friendships with several of his famous clients, regularly socializing with them and finding inspiration in designing for certain women who fulfilled the role of fashion muses.

Valentino was first introduced to the seductive glamour of celebrity clients early in his career, when he worked with the renowned couturier Jean Dessès. Born in Egypt to Greek parents, Dessès regularly created outfits for members of the Greek and Egyptian royal houses as well as the Greek shipping magnate Aristotle Onassis, who later married the widowed Jackie Kennedy. She chose a Valentino gown for the occasion.

The actress who had the earliest influence on Valentino's career was Elizabeth Taylor. The star, who was in Rome filming *Cleopatra*, had heard about an exciting new designer and asked to see his collection, with a view to wearing one of his gowns to the

OPPOSITE Elizabeth Taylor was one of Valentino's earliest muses and the pair remained friends until her death. Here, Taylor greets Valentino with a kiss at a restaurant in Rome in the 1970s.

premiere of the film *Spartacus*, starring her friend Kirk Douglas. As Valentino later recalled of their first meeting: "My mouth was open in front of this beauty. She was unbelievable."

Taylor did wear Valentino to the premiere, a white column gown from his Autumn/Winter 1961 collection. Thirty years later, in 1991, the actress paid tribute to her very first Valentino gown when she appeared at an anniversary celebration of the fashion house in Rome wearing a stunning white, off-the-shoulder dress.

Elizabeth Taylor became a lifelong client and friend of Valentino, although, true to her reputation as somewhat of a diva, was not shy about demanding complimentary dresses. The day after the *Spartacus* premiere gown received so much publicity, "she came to the fashion house," Valentino told the *Daily Telegraph* in 2014, "and wanted seven outfits. She said, 'Oh, you have so much publicity with me today – I deserve this, this, this, this.'"

Taylor was an excellent ambassador for Valentino's clothes, as was Sophia Loren, another close friend since the early days of the Rome atelier and a woman whose seductive style and glamorous Italian beauty he constantly cited as inspiration. But perhaps the most iconic of all his muses was Jackie Kennedy. In 2016, he told icon-icon.com how much she meant to him as both a friend and loyal patron: "She inspired me, supported me during difficult times. With her style, she was able to get people talking about me by getting them to talk about her."

Their relationship began when Kennedy went to Valentino to help her create a suitable mourning wardrobe after the assassination of her husband, John F. Kennedy, in November 1963. Valentino designed six dresses, all in black and white, which he acknowledges sparked a lifelong love of a monochrome palette and one which he returned to time and time again in his later collections.

OPPOSITE Sophia Loren was one of Valentino's favourite actresses from his early years in Rome and they stayed close often attending event together such as this party in New York in 1992.

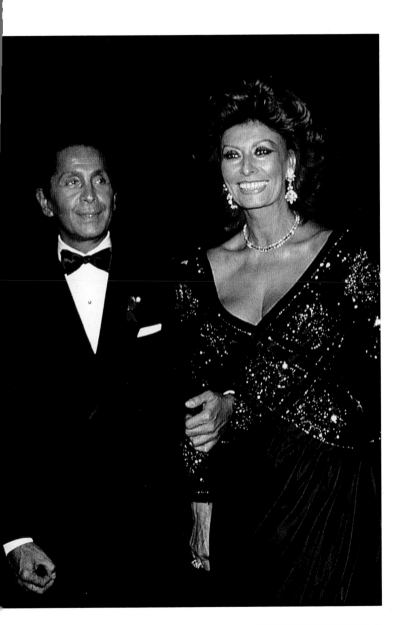

BELOW New York socialite Nan Kempner was an inspiration to Valentino from his early days in New York. Her loyalty to his clothes and her status as a style icon helped his business grow exponentially and the pair remained lifelong friends, pictured here attending a performance of *Swan Lake* together in 1989.

OPPOSITE Naomi Campbell became a muse to Valentino at the start of her career and frequently opened or closed his catwalk shows. Here, the model wears a stunning gold suit for the Autumn/Winter 1992 haute couture show.

After Jackie's death in 1994, Valentino approached her children to see if he could buy back some of the many gowns he had made for her over the years. According to Isabel Jones, writing for *InStyle* in 2019, he considered them to be "among the most beautiful I've ever created".

Remarkably, he was told that many of her dresses, including a number of iconic Valentino creations, had been donated to a convent. Apparently, her son John told the dumbfounded designer: "We couldn't bear the thought of walking down the street and seeing people in her clothes, so we gave them away."

Jackie Kennedy helped Valentino become popular among a set of New York socialites who had great influence over what became fashionable, but it was Diana Vreeland, the legendary editor of *Vogue*, who sealed his reputation as a celebrity designer. Valentino credits her as being an important muse to him, especially with their mutual love of the colour red.

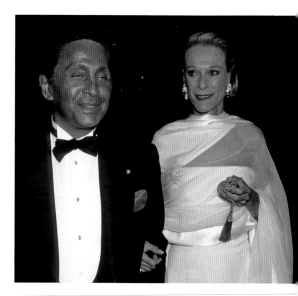

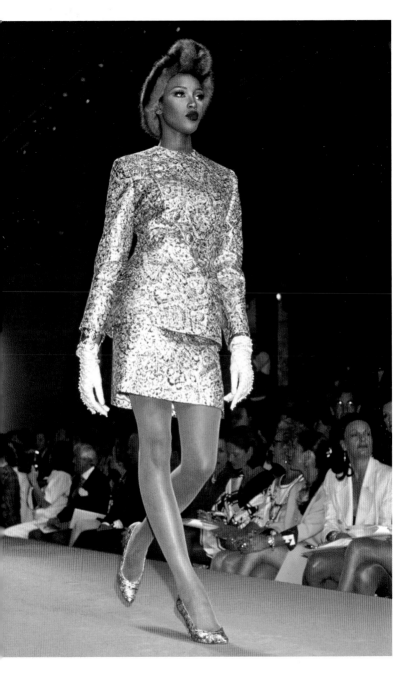

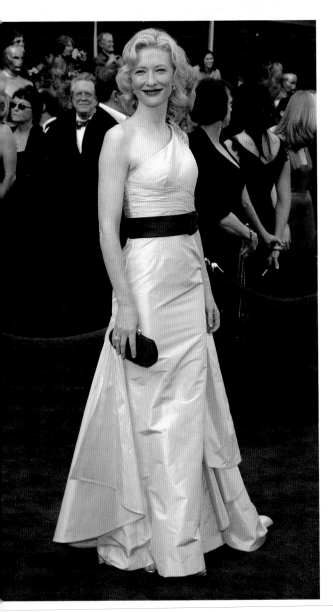

LEFT Cate Blanchett wearing belted yellow Valentino to the 2005 Academy Awards, when she was nominated for Best Actress for her performance in *The Aviator*.

OPPOSITE Victoria Beckham and Valentino at the 2018 Fashion Awards in partnership with Swarovski in London in 2018.

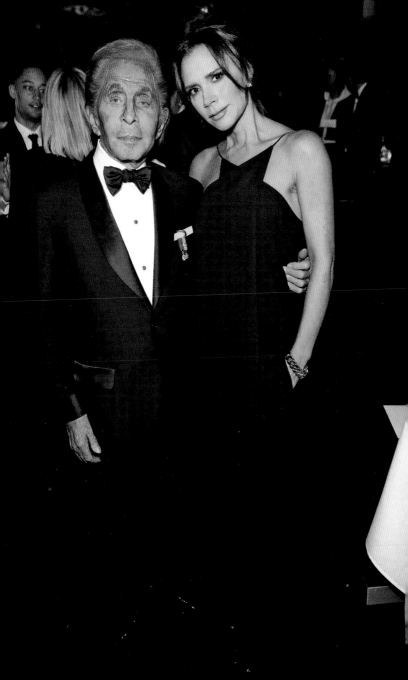

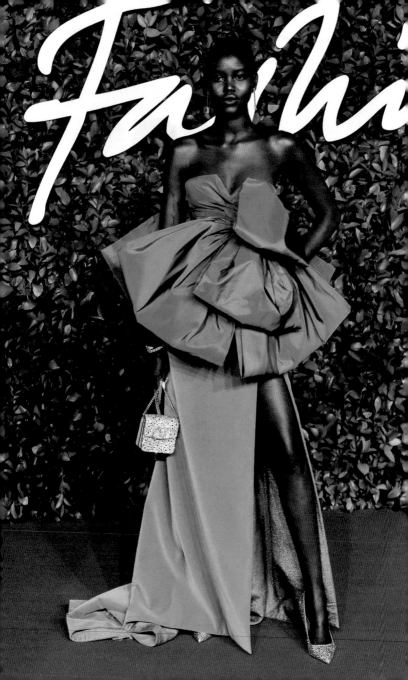

OPPOSITE More recently, Pierpaolo Piccioli has adopted model Adut Akech as his muse, shown here arriving at the 2019 Fashion Awards in a forest-green velvet and taffeta dress by the designer.

In 2017, he told HuffPost: "Diana Vreeland, we called her the Chinese Empress because she loved China and the color red. She was the most important lady in the world at the time, and taught me a way to see and appreciate pictures. I learned a lot from her."

Over the years, a number of models have inspired Valentino, his two favourites being Gisele Bündchen and Naomi Campbell. Indeed, Campbell closed the show for his final appearance before he retired in 2008. She also returned to the Valentino catwalk for Pierpaolo Piccioli's Spring/Summer 2019 haute couture collection and stunned in the final outfit: a revealing black gown with a semi-transparent chiffon bodice and voluptuous, black, ruched taffeta skirt. Bündchen is close to Valentino to this day, having appeared in many of his shows and campaigns from 1998 until her retirement in 2015.

Since Maria Grazia Chiuri and Pierpaolo Piccioli took the helm at Valentino, many diverse modern icons have become muses for the fashion house. Singer Florence Welch has inspired many of the more bohemian, floral styles the pair have created, while actress Olivia Palermo and her red-carpet outfits represent the timelessly elegant aesthetic that is still so intrinsic to Valentino. In 2019, Piccioli appointed model Adut Akech as the face of Valentino, and that same year Janet Mock, award-winning writer, director and producer of the television series *Pose* and campaigner for transgender rights, became the face of Valentino's VSLING bag.

VALENTINO RED

Since his first collection in 1959 and the strapless, rose-adorned bright red cocktail dress named "Fiesta", Valentino ha included a stunning Valentino Red dress every season, and in 2000, a tribute to Valentino's four decades as a fashion designe presented 40 dresses in the couturier's signature bold hue at Rome's Piazza di Spagna.

RIGHT Claudia Schiffer wearing a Valentino Red gown with cutaway bodice to the Valentino 45th Anniversary Celebration Gala at the Villa Borghese in Rome in 2007.

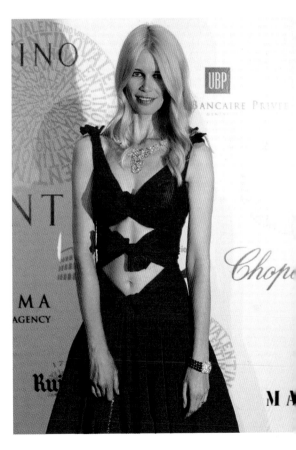

The shade, which Valentino told Hans Ulrich Obrist was "the first colour to have a big impact on me", is unique, and in 2012, the designer described his inspiration for creating it to *Marie Claire*: "When I was young, I went to see the opera *Carmen* in Barcelona and the whole set was red – the flowers, the costumes – and I said to myself, 'I want to keep this colour in my life.' So I mixed a shade with the people who make fabrics – it contains a certain amount of orange – and Valentino Red became an official Pantone colour."

Many celebrities have chosen a Valentino gown in the house's signature colour to appear on the red carpet. Some of the most memorable include Jennifer Aniston, who wore a classic, strapless, flowing version to the Oscars in 2013; Claudia Schiffer, who chose a gown with a cutaway bodice for the Valentino 45th Anniversary Celebration Gala in 2007; and Penelope Cruz, whose red column gown with rose detail wowed viewers at the David di Donatello Awards in 2004.

Other devotees who have worn Valentino Red include Emma Watson and Claire Danes as well as the actress Anne Hathaway, who is, says Valentino, "like a daughter" to him. She chose a vintage Valentino to wear to the Oscars in 2011, inspiring *Vogue* to comment: "The Oscars provided an interesting case study in Valentino then and now. Representing the 'then'

BELOW For the 2011 Academy Award ceremony Anne Hathaway wore a Valentino couture strapless red silk taffeta gown from 2002 with a puffed fishtail skirt featuring the designer's favourite rose motif.

mp was Anne Hathaway in an archival red glamour gown
ting to the mid-aughts. And in the 'now' corner: Florence and
e Machine's Florence Welch in a high-necked, semi-sheer lace
ess from the Spring haute couture collection by Maria Grazia
hiuri and Pierpaolo Piccioli."

Of course, it is not just Valentino's red gowns that appeal
celebrities, and plenty of memorable Oscar frocks can be
ributed to the Italian designer: Julia Roberts wore vintage
ack and white Valentino to collect the
vard for Best Actress in 2001; Jennifer
opez wore a Jackie Kennedy Onassis-
spired mint-green kaftan in 2003;
d Cate Blanchett chose belted yellow
alentino in 2005. Looking further
ck, Sophia Loren wore a heavily
nbroidered Valentino to collect
r Lifetime Achievement Award in
091, and Elizabeth Taylor and Susan
randon have both donned the
esigner to attend the famous awards
remony over the years.

OPPOSITE Gisele
Bündchen wearing a
Valentino Red gown
for the Autumn/
Winter 1999 haute
couture show in Paris.

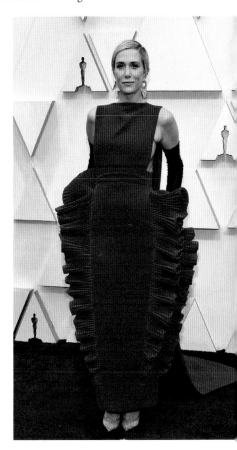

GHT A stunning example of a Valentino Red
wn is this silk dress with extravagant ruching,
en a modern twist by Kristen Wiig for the
20 Academy Awards by the addition of long
ck gloves.

OPPOSITE Queen
Máxima and King
Willem-Alexander
of the Netherlands
were wed in 2002,
the bride wearing a
deceptively simple
ivory Valentino gown
in duchesse satin, with
a high stand collar and
three-quarter length
sleeves.

WEDDING DRESSES

Given the showstopping quality of Valentino gowns, it is
unsurprising that many women have chosen to wear them for
their weddings. The first he designed was the high-necked,
knee-length, off-white couture gown, embellished with
intricate lace, in which Jackie Kennedy married Aristotle
Onassis, but through the decades Valentino has created
stunning gowns for Anne Hathaway, Courteney Cox, Jennifer
Lopez and Elizabeth Taylor, who wore a pale-yellow lace gown
for her eighth marriage to Larry Fortensky.

Ladylike and traditional, his designs have appealed to many
European royals, including Queen Máxima of the Netherlands
and Marie-Chantal, Crown Princess of Greece, who chose
similar styles for their respective
weddings. The designer even came out
of retirement to oversee the creation
of wedding gowns for his close friends
Princess Madeleine of Sweden and
Tatiana Santo Domingo, who married
Andrea Casiraghi (grandson of
Princess Grace of Monaco) in Gstaad
in February 2014 wearing a dramatic,
ruffled Valentino gown with matching
long fur cape to combat the cold.

LEFT Jennifer Lopez married Chris
Judd in 2001 wearing a Chantilly lace
Valentino dress.

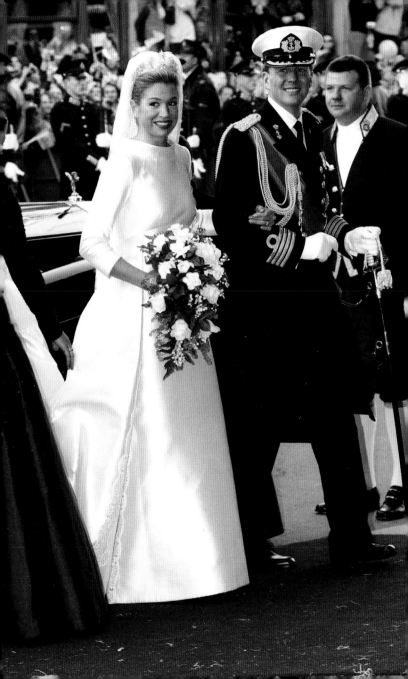

NEW YORK AND BEYOND

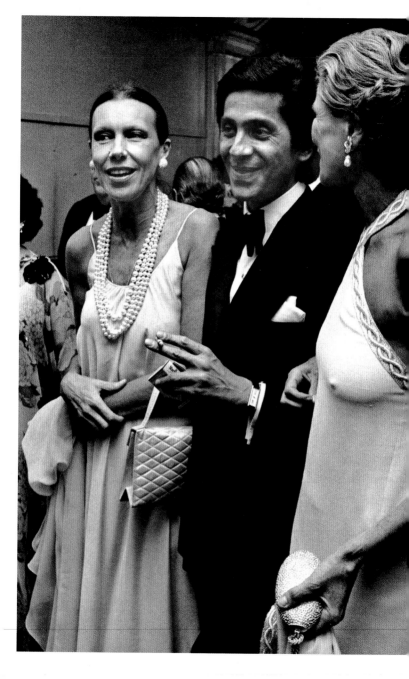

IN WITH THE IN-CROWD

At the beginning of the 1970s, Rome's deteriorating political situation made the city less attractive to the Hollywood elite who had flocked there during the 1960s.

Valentino's salon still saw biannual pilgrimages by American fashion buyers and press as well as clients happy to absorb themselves in the glamour of his new collections, but for the fashion house to move forward, a more international presence was essential.

With a keen eye for business, Giancarlo Giammetti decided to focus on expanding ready-to-wear by outsourcing production to the French garment manufacturer Mendès, which would streamline their operation and increase capacity. A highly reputable firm that worked with top fashion designers, including Yves Saint Laurent and Valentino's mentor Jean Dessès, Mendès was happy to take on Valentino – thanks to the designer's positive presence in the American market.

OPPOSITE Valentino, accompanied here by New York socialite Nan Kempner and Françoise de la Renta, arrives at a benefit show organized by the designer for the Special Olympics in 1976.

Another change made by the fashion house was to move the presentation of Valentino's ready-to-wear collections to Paris although he continued showing his haute couture shows at his Rome salon. It was a bold decision. Most Italian designers stuck to their home turf in Milan because the French fashion world was notoriously hostile to outsiders, yet Valentino's Paris shows were successful, even if the audience were mostly Italian and Americans.

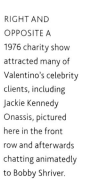

RIGHT AND OPPOSITE A 1976 charity show attracted many of Valentino's celebrity clients, including Jackie Kennedy Onassis, pictured here in the front row and afterwards chatting animatedly to Bobby Shriver.

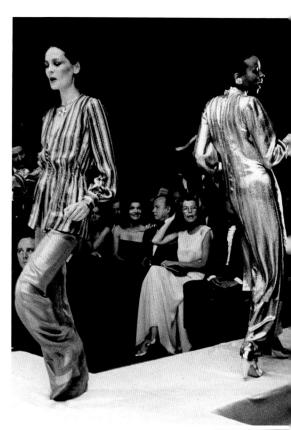

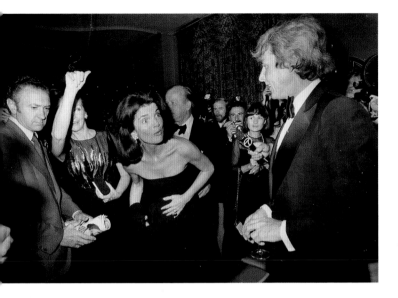

Valentino owed a lot to America. First, to the buyers who
ad flocked to place orders in the early days of his atelier, giving
e designer the financial security he needed for his business
thrive, and second, to the country's socialites. As the decade
rned, Valentino and Giammetti started to spend more time
New York, and in 1970, they opened a much-anticipated
agship store. Finding the right spot was essential. After first
tting up on Fifth Avenue, Valentino moved his boutique
ptown to 801 Madison Avenue, handily situated to cater to the
pper East Side ladies whose loyal patronage was essential to the
nage of his brand.

In a testament to Valentino's own celebrity and love of
tention, the press excitedly reported the opening, which the
ew York Times likened to a Hollywood premiere, observing:
he main attractions were the architecture and the people last
ght at the opening for Valentino's porcelain and glass boutique

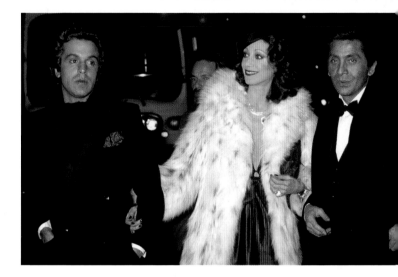

ABOVE Valentino and Giancarlo Giametti with Marisa Berenson as they arrive at the birthday party for Studio 54 co-owner Steve Rubell, hosted by designer Halston in 1978.

. . . and both could be admired from the outside. Because of the heat and the crowds, a lot of people brought their champagne out on the sidewalk . . . and if the crowds let up for a moment, they could always watch Naomi Sims and Marina Schiano, models who were posing in the big glass cylinder that is the shop's show window."

With his popularity showing no sign of flagging and a reliable manufacturer in place to fulfil big orders, Valentino expanded to open stores across the United States, in cities including San Francisco, Boston, Dallas and Palm Springs, where the launch of the Rodeo Drive store heralded another celebrity-filled party.

Already a designer with an excellent reputation, Valentino secured his place in the upper echelons of the fashion world thanks to the endorsement of Diana Vreeland, the legendary *Vogue* editor, and the pair remained lifelong close friends. The formidable fashion doyenne first met Valentino in 1964 and immediately gave him her seal of approval, telling him: "Even a

rth, genius always stands out. I see genius in you. Good luck."

He told *The Cut* in 2015 that when he arrived in New rk, Vreeland went out of her way to include him: "She did erything, just her calls in the morning, inviting us to the eater or a dinner with Andy [Warhol], to a performance of the quid Theater or just a dinner at Pearl's with Jackie [Kennedy], d I felt New York was at my feet."

Valentino's relationship with Andy Warhol was also an luential one. The men moved in the same social circles and re both regulars at the notorious nightclub Studio 54. In 78, Valentino even held his birthday party at the Factory, arhol's New York studio. Warhol also created four silk-screen ints of Valentino during the 1970s. Despite admitting to Hans rich Obrist that he was "not crazy about them", the designer d eventually buy two.

The 1970s social scene was captured in Polaroids taken by

BELOW In 1977, Valentino held a circus-themed birthday party at Studio 54. Carlos Souza and Lorenzo Villarini were among the immaculately costumed guests.

Valentino's partner Giancarlo Giammetti, who shared some of the shots from his personal collection in 2021 to honour the designer Halston. Alongside Halston and Andy Warhol, there are images of Liza Minnelli, Diane von Furstenberg, Bianca Jagger and Elsa Peretti, as well as many of Valentino himself.

Despite his profile as an avid socialite, Valentino was first and foremost a fashion designer. Throughout his career, he was remarkably consistent in his choice of prints, colours and silhouettes, only gently adapting his designs to nod to the trends of the era. Take, for example, the 1970s trend for peasant dresses popularized by the hippies and freethinkers of the time. The loose style was elevated to a new level of elegance by Valentino, who in 1971 created a whimsical off-white dress in flowing organza printed with poppies and wheat, matched with a wide-brimmed straw hat and adorned with silk poppies in his trademark red.

Flowers were a constant inspiration in his fashion designs. As in his homes and studio, where floral arrangements were always on display, his gowns featured a wide variety of printed and embellished flowers and were adorned by blousy organza facsimiles. A romantic at heart, the designer explained his obsession to Marie-Paule Pellé in 1991: "I have paid homage to all the flowers that I love so much through my creations of fabrics and dresses: that was my way of thanking all these marvels that have given me so much pleasure."

This slow evolution of Valentino's designs to accommodate changing fashions is exemplified by his journey through the 1970s. It began with a continuation of the elegant shift dresses and coats of his beloved 1960s, albeit with a slightly longer hemline. But soon, long jackets, wide harem-style trousers and kaftans started to appear, made in the brocades, paisleys and other elaborately printed fabrics Valentino so loved. He found inspiration in Gustav Klimt and the Ballets Russes and drew all

OPPOSITE In 1972 actress Raquel Welc was photographed for *Vogue* wearing a blue Valentino halterneck dress wit a long trailing scarf The gown's carefull pleated skirt shows Valentino's technic skills, while the des reflects the flowing style of the period.

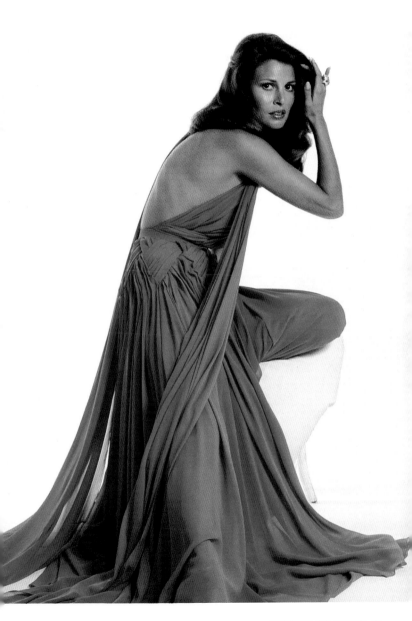

the threads together to create a 1970s silhouette, the essence of which remained true to Valentino's obsession with perfect tailoring and a detailed finish.

Another 1970s favourite of Valentino's was the asymmetrical flowing gown, subtly exposing shoulder, made from a draped silk crepe and edged with hand-sewn, glittering crystals. He did not, like some designers, fall prey to disco fever, always maintaining in his clothes a subtle elegance and femininity that would become his calling card for decades to come.

Other recurrent themes included animal prints, which lent themselves to the long, flowing kaftans and coats of the 1970s, and the black and white graphic patterns to which he so often returned in his designs. As the decade came to a close, the shape of the 1980s began to emerge: long, fitted skirts paired with blouson jackets flaring peplum-style at the waist and the shoulders gradually edging outwards. He also began to appreciate tweeds, a trend that continued throughout the following decade.

After a decade of glamour and regular parties in New York, and opening stores in Paris, London

LEFT Valentino's designs remained remarkably consistent throughout his career. However, he always tweaked his silhouette to reflect current trends. This 1976 *Vogue* editorial shoot features flowing red and black ponchos and wide trousers in Valentino's colour palette, but the shapes are very much of the decade.

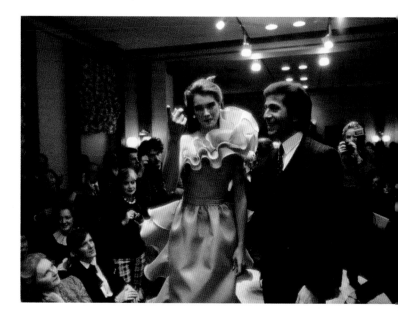

ABOVE Despite being just 15 years old at the time, actress and model Brooke Shields became Valentino's muse, and the star of the haute couture Spring/Summer 1981 catwalk show and campaign.

and Tokyo, Valentino returned in the 1980s to spend more time back in Rome. From a design point of view, he struggled, admitting he couldn't bear the 1980s silhouette. Speaking in 2014 as part of the *Fashion Icons with Fern Mallis* conversation series, he admitted: "I hated those dresses in the 80s, they were out of proportion with shoulders that didn't belong to the fit, they were all terrible, terrible!"

Nevertheless, his signature style seemed to capture something about the new decade and in February 1981, *Time* magazine ran photographs of the actress and model Brooke Shields, with the caption "The '80s Look". Within the issue was a shot of her wearing a red Valentino dress. Very much the face of the moment, Shields was fresh from filming *Blue Lagoon* when she starred in the Valentino haute couture Spring/Summer 1981 catwalk show and the subsequent campaign shot by celebrated

nerican fashion photographer Richard Ballarian. At the time, ields was just 15 years old, yet she nevertheless projected a phisticated glamour combined with a fresh-faced innocence at epitomized Valentino's ideal woman.

In 1982, encouraged by his friend and mentor Diana eeland, Valentino returned stateside to show his Autumn/ inter haute couture collection in New York rather than at s salon in Rome. The extravagant show, held before 800 lect guests at the Metropolitan Museum of Art, was followed an exclusive dinner for 300. In its review, the *New York mes* praised the designer: "Not everyone can give a party in e awesome, vaulting halls and galleries of the Metropolitan useum of Art… Valentino is justly renowned as one of the eat creators and purveyors of alluring, instinctively feminine ening clothes. As one admiring customer says, 'His clothes are

BELOW In 1982, Valentino showed his haute couture collection in New York for the first time, before an audience of 800 exclusive guests at the Metropolitan Museum of Art. Here, Andy Warhol, Lauren Hutton, Mikhail Baryshnikov and Brooke Shields applaud the designer.

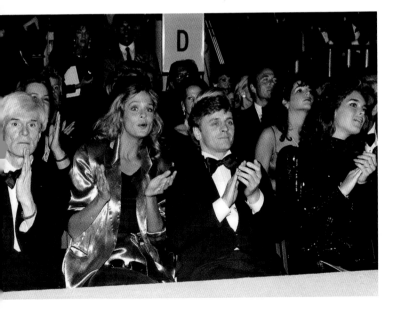

the essence of couture, made of the most luxurious fabrics and colors. One can wear them forever.'"

Valentino's success continued: as well as womenswear and menswear, he launched a range for young adults and children, named Oliver after his favourite dog. His ready-to-wear collections went from strength to strength, appealing to the independent 1980s woman who still wanted to remain feminine, preferring subtle shapes to other designers' severe power suits with the excessively oversized shoulders Valentino so despised. Even when he did present a suit, and bowed to the fashion moment by enlarging and squaring off the shoulders, it was more likely to be a dandyish pinstriped trouser suit, harking back to an older period in style, perhaps with a provocative slashed front and styled with a single red rose. His 1980s colour palette, centred around white, black, grey and red, was broken up by romantic gowns in dusky pinks.

As always, Valentino remained devoted to his love of tailoring and, most importantly, never lost his ability to showcase the elegance of the female form. In the early part of the decade, his two-piece outfits had long jackets, nodding to but just resisting the full inverted triangle demanded by the 1980s silhouette, atop full, flared skirts, while red tights offered a foil to black and grey. Gowns from the period include a gloriously full black and white dress modelled by supermodel Iman, the skirt falling in copious layers, the contrasting white high neck pleated into a wide ruff, its midsection pulled in tight to accentuate her long torso and tiny waist. Ruffles were always a longtime favourite of Valentino and sat perfectly within the decade's fashion aesthetic.

As the years progressed, Valentino embraced plenty of classic 1980s trends – including tweed suits, argyle prints, puffball skirts and shimmering sequins – and in 1983, a *Vogue* editorial much admired his glossy, red, sequinned sheath

OPPOSITE Despite famously declaring his hatred of 1980s fashion, Valentino nevertheless manag to combine his usua refined style with th decade's silhouette – epitomized here by a pale-yellow day suit from 1985, the shoulders only subtl squared off.

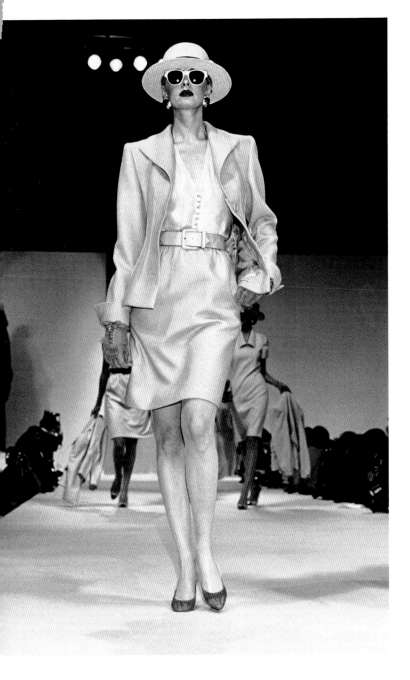

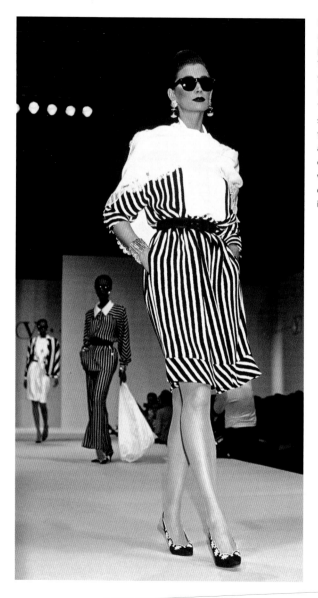

LEFT The monochrome palette was one that Valentino returned to time and time again. For Spring/Summer 1985, he presented several variations on the theme, including a striped, belted dress and a pair of wide-shouldered, double-breasted suit in reverse colourway

ess that appeared almost liquid as it slid over the model's
dy. Black and white remained stalwarts for dresses, which
the 1980s most often came in the shape of cocktail dresses
ncluding a stunning design from 1982 consisted of a black
apless bodice with a large bow at the back, billowing out
to a balloon skirt in chequered black and white taffeta.

By the end of the decade, Valentino's outfits very much had
e feel of what we now associate with 1980s fashions. A black
it from his Autumn/Winter 1989 collection, for example,
atured a double-breasted jacket with square shoulders and
ge buttons, and a straight knee-
ngth skirt. And the following
ar, as the decade turned, a
llection of puffball cocktail
esses appeared for Valentino's
utumn/Winter 1990 show,
itomized by one of his favourite
odels Naomi Campbell strutting
wn the catwalk in a neat black
ess, its bodice in ruched silk
iffon, the flared skirt adorned
ith black ostrich feathers and
ver bow detail.

The 1980s saw key changes as
ell as increased recognition on
e global stage for Valentino. In
83, he relocated his Autumn/
inter haute couture show from
s intimate salon to the nearby
azza Mignanelli, an outdoor
ace large enough to easily
commodate a thousand guests.
nd in 1984, Valentino designed

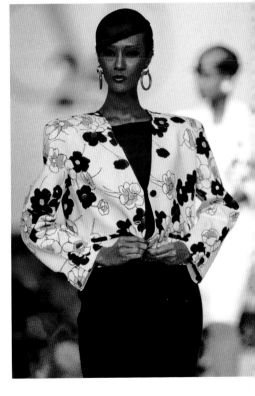

BELOW Flowers have
always been a central
motif in Valentino's
designs, here making
up the pattern of this
cropped jacket from
1985.

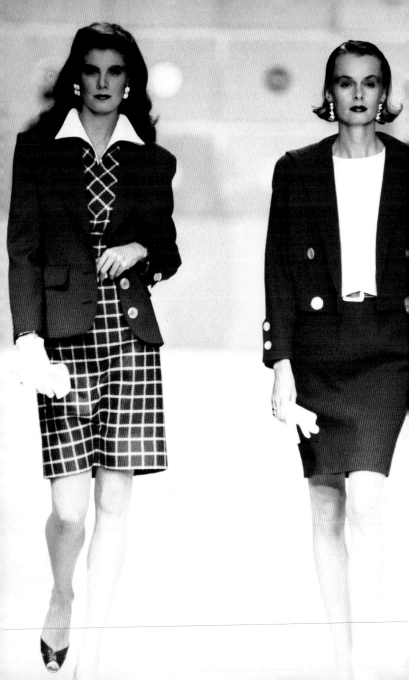

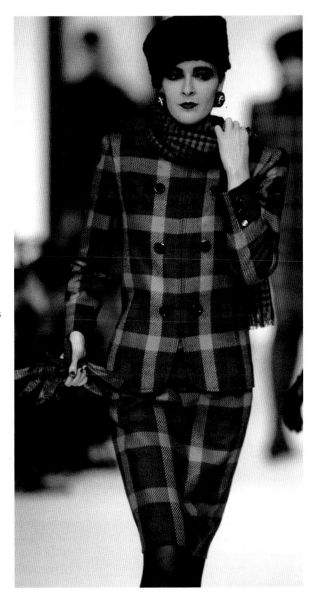

RIGHT Every Valentino collection included a striking evening gown in his trademark Valentino Red. In 1985, a figure-skimming gown, slashed to the waist, is teamed with an oversized cape and large statement earrings.

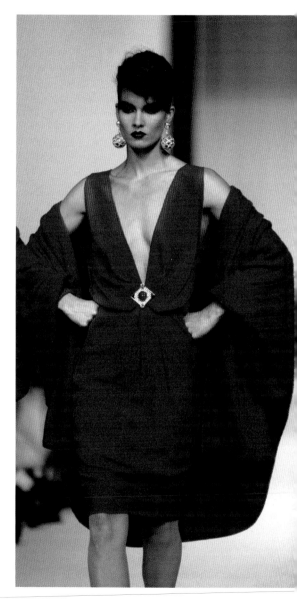

he outfits for the Italian Olympic teams and received an
ward from Italy's minister of industry.

The move to presenting his couture collections in the
pen-air setting of the Piazza Mignanelli was a great success,
nd Valentino continued showing against the backdrop of
s impressive palazzo until 1989, when he moved his haute
outure shows to Paris to join his ready-to-wear collections.
1 doing so, he finally realized his dream from the 1950s: to
e welcomed into the elite group of top designers who truly
elonged in the fashion capital of the world. At the end of the
980s, the Palazzo Mignanelli became the home of Valentino's
usiness operation, housing its management, atelier and
iowrooms, where they remain to this day.

ABOVE By 1988,
on-trend frills and
flounces and polka
dots were becoming
a mainstay of
Valentino's designs,
yet, as always, his
offerings retained
a dignity that other
designers did not
always master.

OVE This still from Spring/Summer 1988 shows Valentino's love of a bold simple colour palette within a collection. Here, bold 1980s-style outfits in vy and silver are offset with bows and buttons in his favourite pillar-box red.

The beginning of the 1990s marked three decades of Valentino, and in appreciation of all that the designer had achieved, a series of lunches, dinners, parties and two exhibitions were scheduled in Rome for June 1991. Praise was lavished upon the designer, with accolades arriving from Valentino's contemporaries including Hubert de Givenchy, Carla Fendi and Gianfranco Ferré. The retrospectives were widely admired, the *New York Times* confirming that they "establish him as a major player in shaping fashion in the last half of the 20th century".

Seeing Valentino's work from the previous 30 years in one retrospective bore out the fact that his style vision had remained extremely clear since his very early years as an apprentice to Jean Dessès. For the exhibition, drawings done by the then 19-year-old Valentino were recreated into a series of dresses for the exhibition, revealing a similar aesthetic to his later designs. As the *New York Times* put it: "As the work of 30 years was gathered

BELOW In 1991, an exhibition of 2,000 of Valentino's outfits along with many of his original drawings was held in Rome. Here, the designer is seen leafing through his sketchbook of illustrations, surrounded by mannequins wearing his designs from the previous three decades.

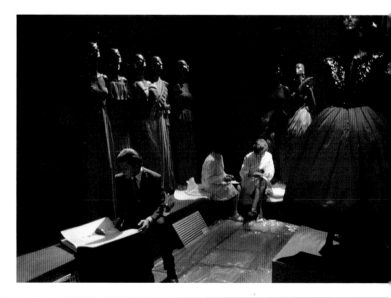

LEFT A series of exhibitions and galas were held in the early 1990s to celebrate 30 years of Valentino's success. Here, in 1992, Brooke Shields attends the gala Valentino: Thirty Years of Magic.

OPPOSITE Christy
Turlington walking
the runway for
Autumn/Winter 1990
in a high-necked
purple minidress
with exquisite lace
detailing.

together, grouped not chronologically but by themes, it was
clear that Valentino had his basic ideas clearly in his head at
the beginning of his career; he simply refined them as he went
along, bringing more assurance and finesse to his work".

The conclusion on seeing the selection of outfits – including
2,000 from the Valentino archives and 700 contributed by
clients – was that the "effect was cohesive as well as dazzling."
It left "an impression of delicacy and sensitivity, of glamour as
well as grandeur".

The early 1990s, trend-wise, had not moved on much from
the short dresses of the late 1980s, which were still very much
in vogue. As ever, Valentino refined his version of the look for
his Spring/Summer 1992 ready-to-wear collection by adding
scalloped edges to his bodices and choosing an array of girlish
floral prints and pastel colours. More grown-up were the
geometric-printed two-pieces, with belted unstructured jackets
teamed with contrasting print trousers. Above all, everything
was feminine, glamorous and exquisitely crafted.

Haute couture collections from this period saw Valentino
indulge his love of unadulterated glamour: a young Christy
Turlington walked the runway for Autumn/Winter 1990 in a
purple minidress with exquisite lace detailing completed by a
high Victorian-style neckline. And in his Spring/Summer 1993
couture collection, the traditional finale of a wedding dress
came in the form of a corseted bodice flaring to clouds of white
organza, all topped by an Edwardian-style hat and veil. Perhaps
the most stunning from the 1990s was his Autumn/Winter
1994 all-black, high-neck blouse and skirt accessorized by a
hat shaped like a pagoda, which was later included in the 2015
Metropolitan Museum of Art's Costume exhibition, China:
Through the Looking Glass.

OPPOSITE Valentino's
penchant for polka-
dot patterns and
ultra-feminine dresses
with plenty of ruching
are exemplified in this
white and red chiffon
gown worn by Claudia
Schiffer for Spring/
Summer 1992.

RIGHT Plaid became
a favourite of
Valentino's Autumn/
Winter collections
from the late
1980s. Here, Naomi
Campbell wears a
glamorous, fitted,
black and white
neck day dress in
1992. The large bow
is classic Valentino
and the addition of
gloves emphasizes
the designer's love of
old-fashioned, ladylike
dressing.

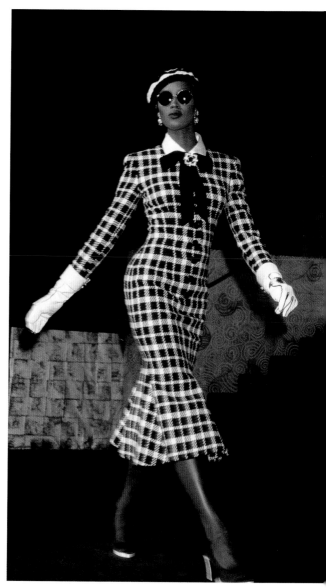

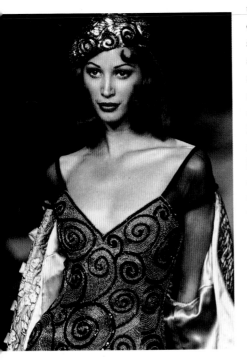

BELOW For Autumn/ Winter 1992, Christy Turlingon wore a minidress covered in gold and black bugle beads with accent swirls of gold sequins. A silk-lined brocade coat and matching hat complete the decadent look that sums up the house's renowned glamour.

By the mid 1990s, the fashion for short, flared cocktail dresses was fading and a more sophisticated aesthetic taking its place. For Spring/Summer 1995, neutral trouset suits, the jacket slipped off to reveal Valentino's trademark deep V neckline, joined petal-front or peplum short skirts with contrasting black jackets. Later in the show, the hemlines dropped and corset-style camisole tops appeared beneath the tailored jackets of pinstripe and checked suits. The cropped bolero was a recurring theme, as were form-fitting dresses, all in a simple palette of black, white and beige.

The late 1990s saw many designers embrace the body-con dress, often using technical fabrics, but Valentino, as always, found a way to take a new trend and make it his own. In this case, he transformed a tight, overly sexualized aesthetic into a sculptural, form-fitting dress, elegant and simple, made from white silk and embellished with sequins or a rose-printed floral. Even when the designer did embrace the shine, as he did in his Spring/Summer 1998 couture show – which featured a gold lamé dress with a deeply plunging neckline, tightly belted and trimmed with crystals – the effect wasn't tacky but simply glamorous.

OPPOSITE For Autumn/Winter 1994 Valentino presented this outfit accessorized by a hat shaped like a pagoda which was later included in the 2015 Metropolitan Museum of Art's Costume exhibition entitled China: Through The Looking Glass.

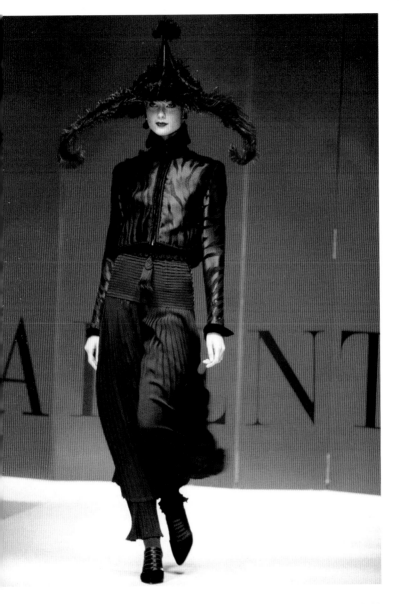

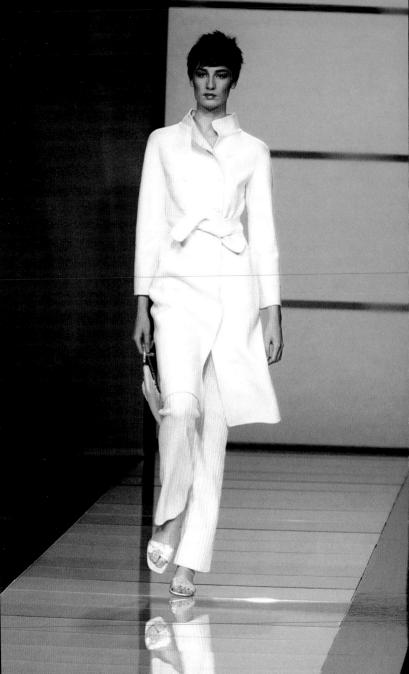

As the millennium approached, Valentino continued doing what he did best – making clothes that made women feel like film stars. His Spring/Summer 2000 collection opened with a stunning all-white outfit, including a belted cashmere coat reminiscent of the beautiful pieces he made for Jackie Kennedy Onassis. Otherwise, the collection dazzled with plenty of florals, from bold poppies emblazoned on flowing trousers to a delicately embroidered lily-of-the-valley appliqué. Colours ranged from orange polka dots to subtler apricot and peach, and textures including lace and crystal embellishments harked back to vintage Valentino. Entering his fifth decade as one of the world's leading fashion designers, Valentino was clearly still in his prime.

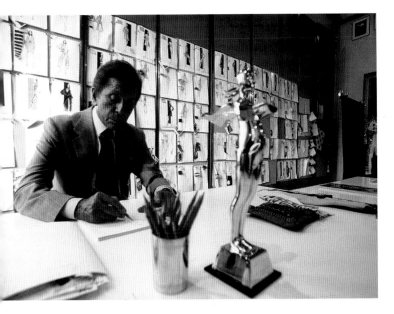

ACCESSORIES

Throughout the latter part of the twentieth century, Valentino's accessories lines were very much in keeping with his fashion aesthetic. Take, for example, the crocodile skin or beaded black evening bags from the 1980s with their jet chain strap, or the statement necklaces featuring the Valentino logo V. But unlike with other designers, there was less hype surrounding his accessories, especially compared to the attention his evening gowns garnered.

In part, this was due to the franchising arrangements that had been put in place during the 1970s. At the time, it was extremely popular for high-end fashion designers to offer licences to global partners in order to boost their profits and expand into new markets. It was a lucrative venture, with the Valentino name appearing on a wide range of accessories, including handbags, ties, belts and shoes. At one point, according to Giancarlo Giammetti, there were 40 franchises in Japan alone. However, as was the

BELOW The Rockstud motif has been hugely popular on handbags too, as exemplified in this white quilted version from 2019.

OPPOSITE An example of the cult Rockstud high-heeled pumps which have become a red carpet staple.

OVERLEAF The 2016 collection of brightly coloured leather cross-body bags with bohemian woven straps nevertheless maintains an edge of rock-star glamour with their metallic stud detailing.

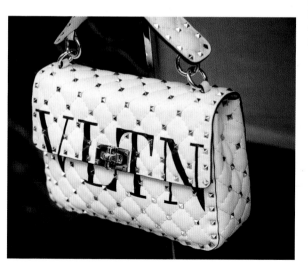

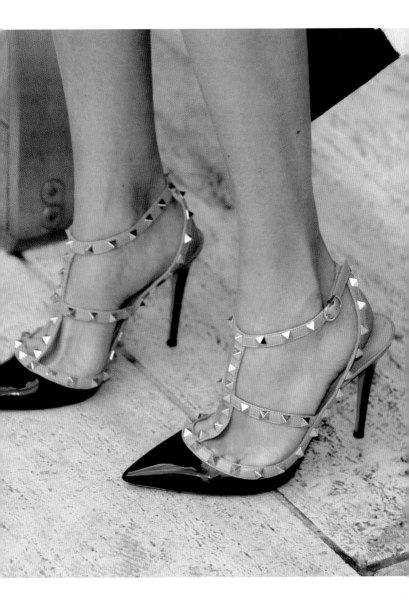

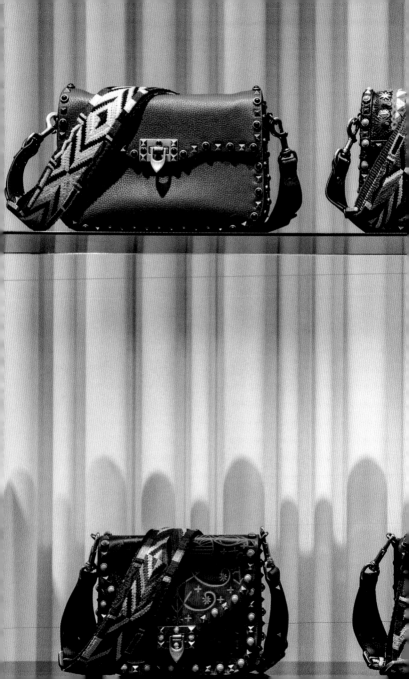

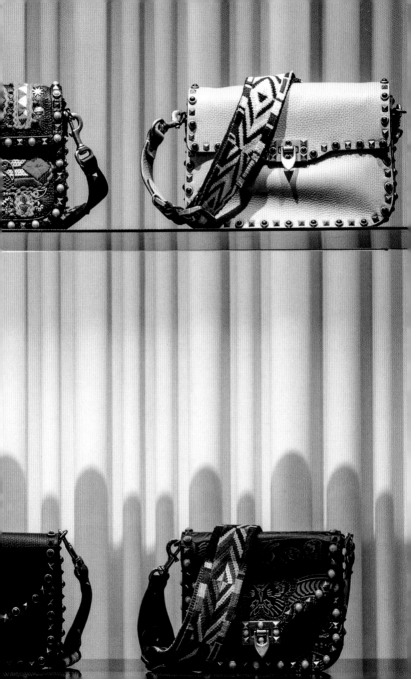

BELOW The iconic V gold logo has appeared in many guises, but most notably as the buckle of the coveted Valentino leather belt.

case with many other luxury fashion houses, Valentino and Giammetti felt that too many of these arrangements diluted the brand's image and, in subsequent years, the company brought much of its accessories design back under direct control.

The turning point came in 1999, when Valentino brought on board two designers who had previously created accessories at the luxury Italian fashion house Fendi. The duo, Maria Grazia Chiuri and Pierpaolo Piccioli, transformed the accessories at Valentino, bringing their quality into line with the expert design and glamour of the label's clothes. Soon, their bags were joining the list of the fashion world's most coveted "It" bags, and other items such as belts, jewellery and shoes became similarly sought-after. Since 2008, when Chiuri and Piccioli took over creative control of ready-to-wear and haute couture, a number of iconic styles have emerged.

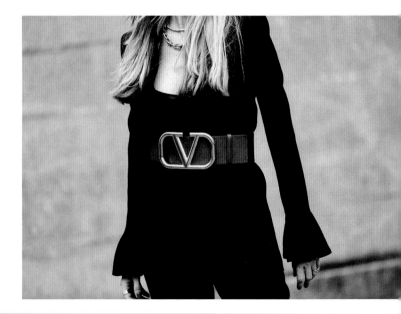

Unsurprisingly, accessories that bear the trademark V logo are ne of the most popular. Belts are made from luxury leathers ch as buffered cowhide and glossy calfskin, the gold emblem oudly displayed, while hats and gloves more discreetly show e wearer's discerning taste. Jewellery is popular too, with the el offering everything from miniature belts in the form of ther bracelets to charms and cufflinks.

The other extremely popular range, particularly among a w generation of younger customers, and one that epitomizes e uniquely Italian brand of glamour for which Valentino is lowned, is the Rockstud range. Shoes such as the killer-heeled ckstud pump, a favourite of celebrities walking the red carpet, d bags in styles as varied as cross-body, clutch and tote cater all occasions, the metallic studs adding just enough edginess make a classic leather bag relevant again.

BELOW When Pierpaolo Piccioli took over creative design at Valentino in 2016, athleisure became part of the fashion house's repertoire, including previously unimagined designs such as this pair of trainers intricately woven from laces.

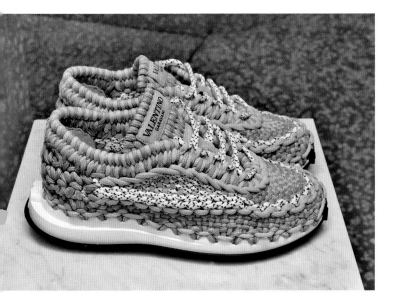

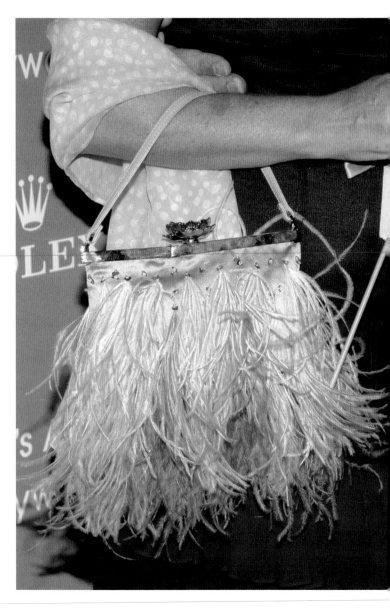

IE TWO VALENTINOS

ice the launch of his own label, Valentino has faced a unique oblem when it came to his accessories lines, which is that shared his name with another designer, Mario Valentino, a oe and bag designer who had founded his own eponymous ther goods business in 1952. In 1979, to resolve the inevitable ie of customer confusion, the pair drew up a coexistence reement which stated that Mario Valentino was permitted to ie and register the full name Mario Valentino or M. Valentino Valentino or the letters MV or V exclusively on the outside, gether with Mario Valentino on the inside".

During the ensuing decades, the mutual agreement more less worked, but as Valentino Garavani grew to become one

OPPOSITE A turquoise Valentino evening bag with feather fringing shows a more delicate side to the brand's accessories.

BELOW A metallic black leather version of the Rockstud stiletto mixes classic Valentino elegance with a modern edge.

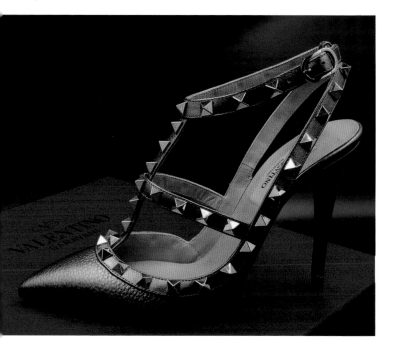

of the world's most famous designers, Mario Valentino was inevitably eclipsed. Mario Valentino passed away in 1991, but the business in his name continued, his products increasingly confused with those of Valentino Garavani, thus allowing the less well-known brand to benefit from the glamour and reputation of his internationally renowned competitor.

Ironically, early Mario Valentino bags were extremely well-crafted in quality leather and clearly marked with the correct designer's name. In fact, the house even employed some top designers, including Karl Lagerfeld and Giorgio Armani at the very beginning of their careers. But by 2013, a deluge of cut-price "Valentino" bags flooded the market, especially in the United States, all marked with the recognizable "V" logo of Valentino Garavani while the Mario Valentino name was hidden away and almost impossible to spot.

As a result, in 2019 Valentino S.p.A. took Mario Valentino and its American licensee Yarch Capital to court, accusing them of deliberately fostering misconceptions in their advertising campaigns by labelling products to take advantage of "Valentino's goodwill in the United States handbag market" and even going so far as to claim in marketing materials that Mario Valentino is "a top designer name that people worldwide are familiar with" – as reported by *The Fashion Law* on 23 July 2019.

The issue continues as Valentino Garavani bags become more and more popular. Sadly, it is necessary today to ensure that the Valentino bag you are buying comes from a reputable seller.

PERFUME

In 1978, Valentino joined many of his contemporary designers by releasing his first fragrance. Simply titled "Valentino", his debut

OPPOSITE A stunning feather-covered evening bag in rich orange and red hues from Autumn/Winter 2001 matches the model's silk fishtail gown perfectly.

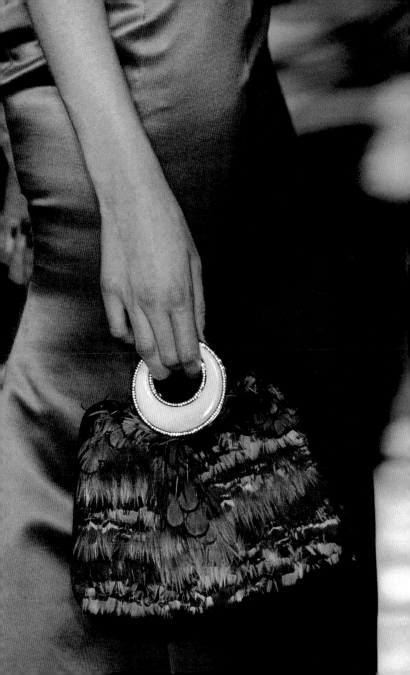

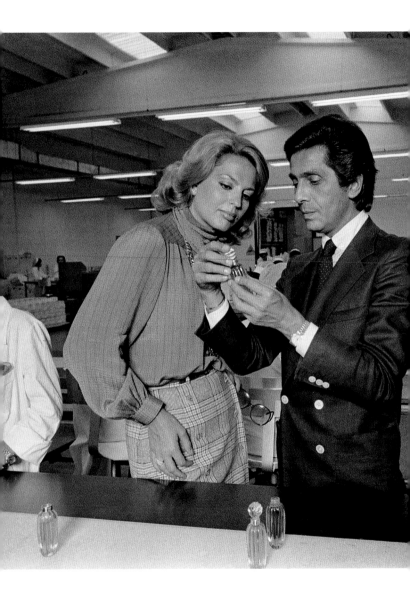

scent was created by Givaudan, a perfumer founded in 1895, which in 1946 started its now famous school to "train noses". Alumni include some of the greats of the twentieth century, such as Jean-Claude Ellena of Hermès and Jacques Polge, Chanel's former head perfumer.

The green and floral fragrance was designed to complement not just the glamour but also the romantic nature of the Valentino woman, and came in an elegant bottle created by Pierre Dinand, the man behind many of the world's most iconic perfume bottles.

Since then, the house of Valentino has released 39 fragrances for both men and women, all in keeping with the luxury aesthetic of the brand, many making an olfactory statement as grand as one of Valentino's beautiful gowns. Some of the most popular are Donna, V Ete and Valentina, created in 2011 by master perfumers Olivier Cresp and Alberto Morillas and presented in a perfectly round bottle adorned by a single, elegant flower. Scents for men include Valentino Uomo, Uomo Intense and Uomo Noir Absolu.

LEFT In 1978, Valentino released his first perfume. He is pictured here with the then president of Valentino perfumes, Ira von Fürstenberg.

OVERLEAF LEFT The flower-embellished bottle of Valentino Valentina.

OVERLEAF RIGHT In 2014, Valentino relaunched its classic men's fragrance Valentino Uomo.

HOMES
AND
INTERIORS

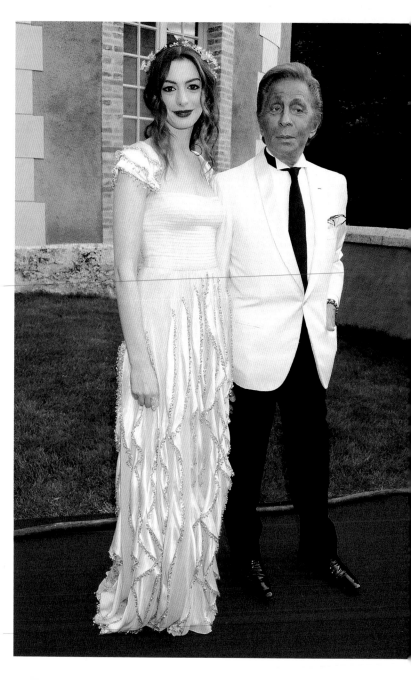

PARIS, ROME, LONDON, NEW YORK, GSTAAD

"It's certain that if I hadn't become a couturier,
I'd have been an interior designer."

VALENTINO GARAVANI,
Architectural Digest, *July 2016*

Valentino Garavani has often been dubbed the Emperor of Fashion – and rightly so, given his long career creating some of the most fabulous dresses in the world. But his taste for opulence is not limited to the catwalk, and Valentino is as well known for his extravagant interior style and lavish entertaining in his many homes around the globe.

Between them, Valentino and his long-time partner Giancarlo Giammetti boast prime residences in Rome, Paris, New York, London and Gstaad, which they share freely, although the pair are no longer linked romantically and have never officially lived

OPPOSITE Valentino and Anne Hathaway, wearing a beaded white Valentino gown, at his home outside Paris, Château de Wideville, where the designer hosted the 2011 Love Ball to raise funds for supermodel Natalia Vodianova's Naked Heart Foundation.

together. In the 2014 book *Valentino: At the Emperor's Table*, André Leon Talley, the designer's friend and former editor-at-large of *Vogue*, described how Valentino "designs his luncheons and dinners, in all of his homes, the way he has created crescendos and allegros vivace throughout his forty-plus-year career as one of the greatest haute couture designers and high-fashion leaders in the world".

CHÂTEAU DE WIDEVILLE

The grandest, and perhaps the favourite, of all Valentino's homes is the Château de Wideville, just outside Paris. The seventeenth-century, eight-bedroom house, with an estate comprising of 280 acres of exquisitely designed and manicured gardens, was originally built by Louis XIII's finance minister, and Louis XIV later installed one of his mistresses there. Valentino purchased it in 1995 and immediately worked with the legendary interior decorator Henri Samuel, then in his nineties, to decorate it. The style is classic Valentino, regal in a way befitting a château of such grandeur, yet still inviting, and showcasing his clear love of Chinese artefacts, including porcelain, figurines and a series of early nineteenth-century Chinese ancestor portraits looking down over the château's magnificent central curved staircase.

Always looking to create new and intimate spaces, Valentino restored the estate's pigeonnier into a workspace and hideaway described by *Architectural Digest* in 2012 as having "a decor redolent of 1920s Shanghai".

Valentino and Giammetti spend several months each year at Château de Wideville, hosting parties during Paris Fashion Week as well as other grand events, including the 2011 Love Ball to raise funds for supermodel Natalia Vodianova's Naked Heart Foundation.

OPPOSITE Had he not been a fashion designer, Valentino has always claimed that he would have been an interior designer – and his style is as flamboyant in both areas. This four-poster bed in his atelier was designed by Valentino in 1972.

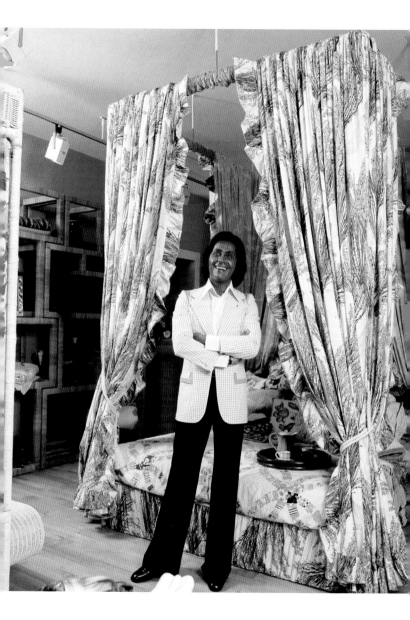

ROME: APPIAN WAY

With his business still based in Rome, the designer keeps a home there. Valentino's villa on the Via Appia Antica is far more than a "simple country house", as the designer has been known to describe it. Bought in 1972 and renovated in collaboration with the esteemed architect and set designer Renzo Mongiardino, the villa is an assault on the senses. Again, Valentino's love of chinoiserie is obvious in the form of wallpaper and ceramics, but his obsession with floral motifs is perhaps the most striking. The decor is a riot of colour, print and texture, with needlepoint carpets, rich embroidered velvet and lush oversized printed floral upholstery. On the wall hangs a red-accented Miró watercolour, a fitting tribute to Valentino's signature colour.

The interior design verges on the overwhelming but manages to work as a whole, just as Valentino expertly pulls together his extravagant catwalk collections. His delight, as well as his confidence, in his interior design skills is infectious. Speaking to *Architectural Digest* in 2016, he proclaimed: "If you have taste, you can mix it all together."

LONDON: HOLLAND PARK

In 2001, Valentino bought a townhouse in London's Holland Park, a discreet and extremely expensive enclave beloved of international celebrities. Describing the location to *ES Magazine* in 2014, the designer said: "It's perfect for me because I'm from a small town in northern Italy called Voghera, so I like places where you step out of the door and there is greenery and no traffic."

The house was decorated by Jacques Grange, the French interior designer well known for his ability to mix styles, and manages to combine rococo opulence with stark minimalism in a way few could achieve. The effect is pure Valentino, who also likes to juxtapose periods and styles to create a cohesive interior

first, it seems pure art deco, with 1930s furniture against a muted palette with black and white accent colours – but look more closely, and there is traditional nineteenth-century English furniture that nods to the heritage of the house. As with all of Valentino's houses, the walls are hung with stunning works of art – with a Francis Bacon, a Damien Hirst and a striking Andy Warhol offering well-considered notes of contrast.

NEW YORK: FIFTH AVENUE

The apartment that Valentino and his partner Giancarlo Giammetti currently share in Manhattan is situated in the prime real estate of Fifth Avenue, overlooking both the Frick Collection and Central Park, and it, too, was renovated by Jacques Grange. Giammetti bought it for $18.5 million in 2010, after the couple sold their previous, smaller residence in the city because Valentino realized that he would want to spend more time in New York after his retirement.

The light and airy space is filled with many precious artefacts and artworks – the entrance hall alone boasts a Mark Rothko and a pair of Tang dynasty horses. Again, the interior has an art deco feel, with bold black outlines to the walls and plenty of mid-century furniture by designers such as Karl Springer. Warmth is introduced by rosewood and walnut flooring, which extends to fill a lined hallway, and welcoming furniture has been specially designed by Grange and upholstered in a myriad of rich textures and prints, including a Pierre Frey tiger stripe.

Valentino and Giammetti's passion for art is most obvious in this space, their taste ranging from a pastel by Richard Prince (part of his Nurse series) to a Basquiat triptych, a Roy Lichtenstein and a David Hockney. The pair are serious collectors: a camouflage Andy Warhol hangs in the dining room and a Picasso takes pride of place in the sitting room.

It is clear from this latest project that Valentino's dedication

to his homes is equal to that of his fashion design. Speaking in 2010, he admitted to *Vanity Fair*: "I am only good for two things in this world, designing dresses and the decoration of houses."

GSTAAD

The chalet that Valentino owns in the Swiss ski resort of Gstaad is one of his oldest homes and a favourite in which to spend Christmas and New Year with friends, skiing and socializing. Far more traditional in feel, it has a cosiness that belies the designer's reputation for liking only high glamour. The rooms are panelled in local wood, Irving Penn photographs line the walls and backlit shelves highlight his collection of European faiences, tureens and barbotines. A favourite table centrepiece when hosting his famous feasts is one of his nineteenth-century Meissen swans.

In *Valentino: At the Emperor's Table*, the designer explains how he loves to entertain, and the attention to detail that he gives his exquisite table settings, themed to fit the home in which they are served, is equal to that of any catwalk show.

ART

It is impossible to speak of Valentino's interior style without recognizing his extensive art collection. From his first major purchase of a "Picasso with beautiful colours" to the abstract expressionist Willem de Kooning, the figurative British painter Peter Doig, and the German visual artist Gerhard Richter, Valentino possesses a wide-ranging aesthetic taste.

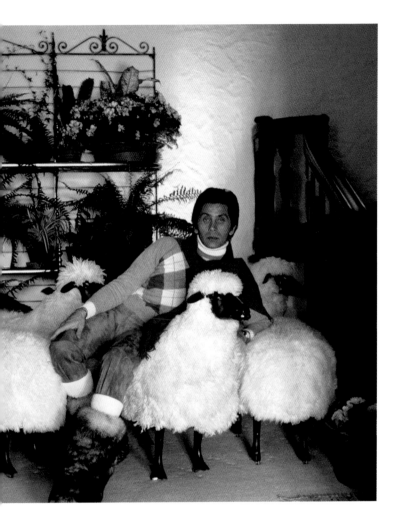

ABOVE His ski chalet in Gstaad is one of Valentino's
[o]dest homes. Photographed in 1977, the designer
[re]clines against the sheep sofa designed by French
[hu]sband-and-wife artist duo Claude and François-
[Xa]vier Lalanne.

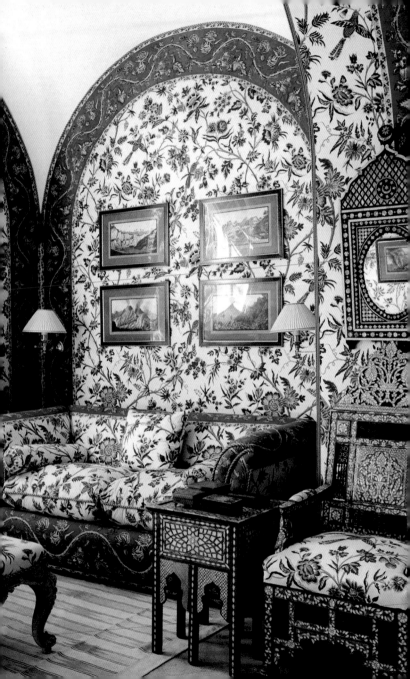

OPPOSITE Valentino's
love of print and
pattern in his interiors
exemplified by the
Moorish-inspired
decor of his house in
Capri.

In a 2015 interview for *System*, Valentino spoke to Hans
Ulrich Obrist, the Swiss art historian, curator and critic,
about his love of beautiful paintings and bold colours. He also
discussed his relationships with artists including Basquiat, who
fell asleep after attending one of his catwalk shows, as well as
Andy Warhol, who did a portrait of him in 1970 and with
whom he socialized.

"When you see a beautiful painting, a Picasso or a Basquiat,
you try and put it into your collection – especially Basquiat
because I did a collection a not very long time ago in the 1990s
where I showed several Basquiat details in the dresses . . . His use
of colour is the strongest out of all those figures. He has always
fascinated me."

As well as paintings, Valentino collects more sculptural
pieces, one of the most unusual of which might be the life-
size sheep by French husband-and-wife artist duo Claude and
François-Xavier Lalanne. Over half a century of work, the artist
duo have long been inspired by the animal kingdom while
paying homage to the traditions of surrealism and art nouveau.
The skin-covered bronze cast sheep were part of Sheep Station,
the inaugural exhibition at Manhattan's Getty Station, the
former filling station. The Lalannes' work was already a favourite
of fashion designers including Karl Lagerfeld, John Galliano and
Tom Ford, and flocks of the sheep have also found their way
into the homes of Yves Saint Laurent and Marc Jacobs.

SELLING
UP BUT
NOT OUT

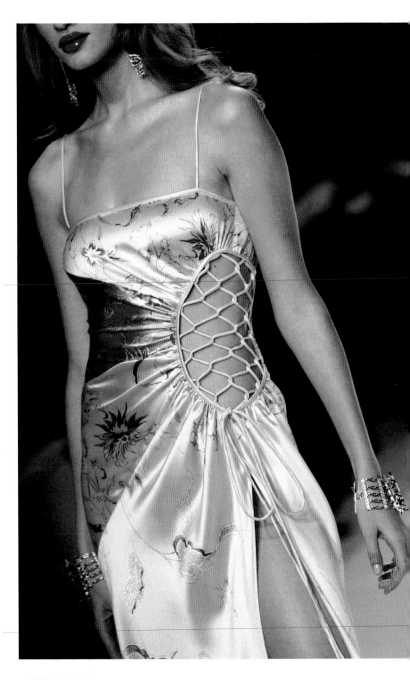

ONWARDS AND UPWARDS

In 1998, Valentino and Giammetti sold their company to Italian fashion and media conglomerate HdP S.p.A. for $300 million. Unfortunately, despite Valentino staying actively involved as designer and receiving plaudits for his seasonal collections, poor business decisions led to the brand failing to make a profit for several years, even registering a loss of €29 million in 2001.

As a result, Valentino S.p.A. was sold once again the following year, this time to the Italian textiles house Marzotto Apparel. Rumours at the time implied that the extravagant lifestyle enjoyed by Valentino and Giancarlo Giammetti, with their private jets and large entourage of staff, was partly to blame for the company's financial loss.

It is certainly true that the pair, renowned for their expensive tastes even within the notoriously big-spending fashion industry, have enjoyed a high-maintenance lifestyle. An insight into their exacting standards was given in *Vanity Fair* by Matt Tyrnauer, who also directed the documentary *Valentino: The Last Emperor*.

OPPOSITE Chinoiserie has always been a passion for Valentino in his homes and occasionally found its way into his fashion designs, such as on this yellow printed silk gown with cutaway detail from Spring/Summer 2004.

Watching the pair prepare to travel, Tyrnauer observed the three buses needed to get from the airport terminal to their private jet, "one to move Valentino, Giammetti, and staff, another for luggage, and a third to transport five of Valentino's six pugs".

He went on to note: "A staff of nearly 50 is employed to maintain Valentino's 152-foot yacht and his five homes." As John Fairchild, then editor-at-large at *Women's Wear Daily* and *W*, noted: "Valentino and Giancarlo are the kings of high living."

But this snippet of their rarefied existence was nothing new. Valentino had always enjoyed the high life, and his reputation for appreciating luxury himself imbued his clothes with extra glamour. Even when his business was going through a rocky patch, Valentino himself was being showered in praise and respect for his achievements, now stretching over four decades.

In 2000, to celebrate his long and successful career, a show featuring 40 Valentino Red dresses was presented at Rome's Piazza di Spagna. In 2003, playing on the reputation of Valentino Red, the fashion house launched the urban-focused REDValentino line. Standing for "Romantic Eccentric Dress", the line was designed to be edgy and streetwise and appeal to a younger shopper.

The new millennium saw no sign of Valentino's design brilliance fading as he presented his trademark combination of luxe evening dresses and beautifully tailored daywear, including suits for "ladies who lunch", which would not have looked out of place on any one of Valentino's socialite clients over the decades. As *Vogue* noted about the Autumn/Winter 2000 collection: "His real-life ladies lead a pampered limo life, apparently unchanged since the Duchess of Windsor's day."

In his collections during the early 2000s, Valentino continued the ethos of elegant clothes without overly indulging in the trends of the moment. A 1980s revival among his peers was flatly ignored by the Italian designer, his spring palette ranging from

utral white and beige, through greys to black, with the ever-
esent pop of red. He presented geometric stripes, checks and
lka dots in black and white as well as simple monotone outfits
at harked back to his breakthrough 1960s collections, and as
ways, there were exquisite gowns, embellished with crystals and
nbroidery or generously full, crafted from metres of organza.

Several of Valentino's collections, especially his haute couture,
ood out. A notable example is Autumn/Winter 2002, when
e designer presented a collection full of chinoiserie, something
e has always had a passion for when it came to decorating his
omes. Snakes, a symbol of elegance in Chinese mythology,
ere a central theme, worn as pieces of jewellery or even as a
nd of dramatic headpiece. Coats and capes were elaborately
nbroidered with Eastern-inspired motifs and plenty of satin

BELOW Always
hands-on, Valentino
gives a model a last-
minute adjustment
backstage during his
Spring/Summer 2005
show.

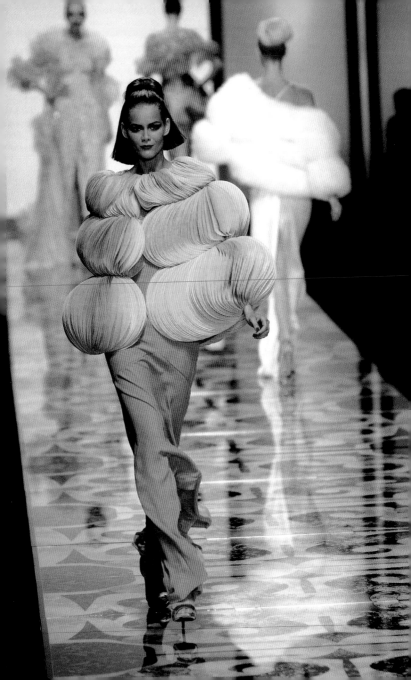

lent the show even more glamour than usual.

Here was a collection in which Valentino appeared to be nodding towards the "dark side", as *Vogue*'s show report noted, but "ultimately nothing diverted Valentino from his primary goal of making women look gorgeously pretty".

The same was true for his couture show for Spring/Summer 2005, a tongue-in-cheek homage to the global relevance of fashion. His outfits, given names like "Sevilla, No Bull" and "Courting Versailles" were not really about diversity of style, although the backdrop took the audience on a whistle-stop tour of some of the world's most iconic landmarks. It was, in fact, just Valentino putting on a show for his wealthy clientele, who were increasingly as likely to come from India or Russia as from Europe or America. The outfits were pure elegance, from ladylike suits for those who still lunch to fabulous gowns for evening soirées. The finale, entitled "Milano, Callas Forever", saw Naomi Campbell in an opera-worthy voluminous gown with a fitted bodice, overlaid with beaded appliqué lace and an organza tiered skirt edged with lace. One velvet shoulder strap finished things off perfectly. As *Vogue* put it, Valentino still designs for an "old-school wonderland where women are treated as creatures made of spun glass".

Valentino's final years before retiring in 2008 continued to display his brilliance at creating exquisite clothes to make women feel beautiful. Ready-to-wear collections focused on elegantly tailored daywear, with colour palettes ranging from beige, caramel and black tones in 2003 to Valentino's favourite monochrome in both 2004 and 2006. In between, Autumn/Winter 2005 was a vision in Valentino Red, stunning when offset against jet black, with a re-emergence of the argyle print that he had returned to over the years. And, of course, every season included a series of seductive frocks, embellished, embroidered and inevitably destined for the red carpet.

Spring/Summer collections conjured up a more playful feel.

In 2004, confections of lace and chiffon were presented compl
with satin bows and butterfly motifs. But there was a more
sophisticated nautical theme too, with outfits such as tailored
white sailor trousers paired with a simple navy silk top – very
much the kind of thing Jackie Onassis might have worn on her
husband's yacht – and perfect for a new generation of socialites
holidaying on Cape Cod.

A year later, Valentino presented a dramatic change in tone,
offering a wardrobe designed for a globe-trotting traveller. The
collection was a riot of sunshine-filled floral prints with a colour
spectrum ranging from lime green and citrine to oranges and
yellows, barely toned down by a muted terracotta reminiscent of
clay buildings of Morocco and Spain. All of this came in the for
of chiffon dresses, swinging, pleated skirts and neat, beaded jack

For Spring/Summer 2006, as rumours about his impending
retirement were circulating, Valentino returned to his pared-do
black and white, broken up by a selection of Asian-inspired flo
silk dresses, skirts and trouser suits. In Spring/Summer 2007,
when old-school ladylike style was back in fashion, Valentino w
in his element, with *Vogue* proclaiming that "the lifelong them
of his work – delicate dresses, lace, bows, and, of course, the co
red – seem quite beautifully relevant at a time when so many
edgier upstarts are stabbing around the territory".

And therein lies Valentino's brilliance. His ability to retain
a consistent design ethos over a period of 45 years is both an
extraordinary feat and the reason that Valentino has been so
successful for so long.

Valentino's final show season was for Spring/Summer 200
While the temptation might have been to offer a retrospective
display of decades-old classics, Valentino showed a collection
of eminently wearable, pretty, light and airy dresses that migh
almost have been called youthful. Nothing in his selection of
colourful minidresses could be said to be old-fashioned or sta

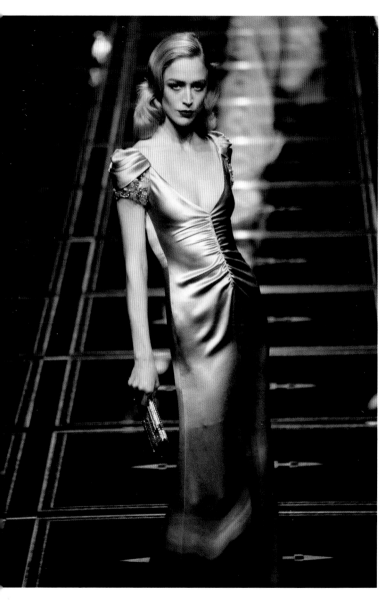

RIGHT Valentino finally retired after half a century in the business after his haute couture Spring/ Summer 2008 show. Here he acknowledges the admiration from the audience for his extraordinary contribution to the world of fashion. He is surrounded by models wearing dresses in his iconic red.

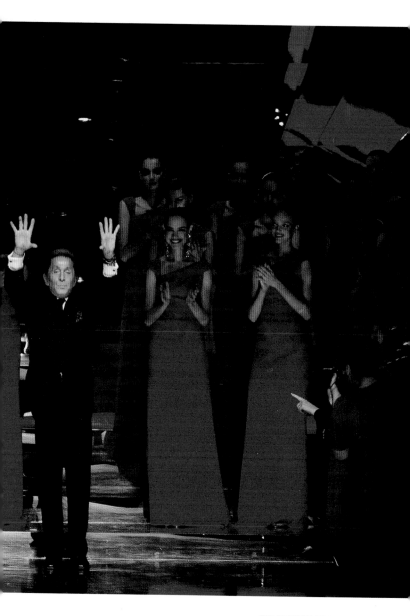

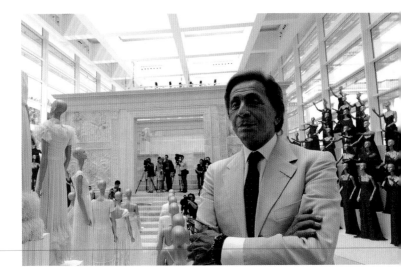

ABOVE With rumours of Valentino's retirement circulating, a number of retrospectives were organized, including an exhibition of 200 outfits to celebrate his 45 years as a fashion designer. Needless to say, his exclusive red gowns and landmark white collections were heavily represented.

Instead, pale pinks gave way to yellows, purples and greens, and even a pink so bright it was almost neon. A multicoloured block stripe with a semi-transparent layer and a shiny, liquid, asymmetrical, off-the-shoulder, body-skimming dress were Valentino's way of saying he could still be modern. As the show progressed, he moved on to a series of cocktail frocks with the flamboyant twists he can never resist in the form of ruffles and ruches, bows and beaded fringes. Inevitably, some classics did emerge in the form of a series of black and white-polka dot outfits and, of course, the statement evening gowns.

Valentino's very last appearance, in a room filled with projections of models wearing gowns in his iconic red hue, was the haute couture Spring/Summer 2008 show. It was full of what his fans had come to expect. Aside from the flattering, tailored day suits, it was the exquisitely crafted gowns that most reminded the audience of why Valentino had been at the top of his game for so long. Made from the finest silk, taffeta and

ce, semi-transparent veil-like layers of the most delicate floral embroidery lifted the more formal gowns to another level. Among the glossy gold, white and monochrome dresses, there were eye-catching pops of bright colour and bold oversized floral prints. The silhouettes ranged from an elegant 1950s knee-length black pencil skirt and contrasting flare-sleeved tailored short jacket, complete with elbow-length gloves, to a floor-length yellow floral-printed silk chiffon dress reminiscent of the Belle Époque, complete with oversized floral-trimmed hat. A culmination of decades of honing his favourite styles to perfection came together, and here was a show in which Valentino should rightly have taken pride.

In 2008, the exhibition Valentino: Themes and Variations, was held at the Museé des Arts Decoratifs in Paris. Curated by Pamela Golbin, it drew together his favourite recurring themes from throughout his long career. Showcasing his technical expertise, his love of ornamentation, and the ways in which he played with different lines and silhouettes over the years, experimenting with volume, pattern and texture, this was a remarkable collection of his most memorable dresses, and a fitting tribute.

VALENTINO: THE LAST EMPEROR

A celebrity in his own right, Valentino not only appeared in a cameo role in the 2006 film *The Devil Wears Prada*, but in 2008 was the subject of a documentary entitled *Valentino: The Last Emperor*.

Directed by Matt Tyrnauer, the short film offered a rare glimpse into the lives of Valentino and his business partner, one-time lover, and lifelong friend, Giancarlo Giammetti, in the two years preceding their retirement. The film's intention was to examine the ongoing struggle between the high art form of Valentino's haute couture and the challenges of navigating the world of business, represented by Giammetti, but it also revealed a story of the remarkable relationship between the two men as well as the genius and legacy of Valentino as a fashion designer.

Speaking to IndieWire in 2009, director Matt Tyrnauer said: "They have a relationship unlike any I have ever seen before. It's unique. People frequently say, Valentino and Giancarlo, it's like a marriage. Well, I'd say it's more than a marriage. It's a supernatural bond that has lasted for 50 years. They are part of the same person, really. So close, and so interdependent."

Valentino's status as one of the truly great designers of the twentieth century is summed up by an extraordinary capture by Tyrnauer of Karl Lagerfeld embracing a tearful Valentino backstage after his final show. The legendary German designer leans in to Valentino and says: "Compared to us, the rest just make rags."

As Tyrnauer put it, speaking to *Paper* magazine in 2020, "we were able to capture an immortal moment in the history of fashion. These were the last emperors – and they knew it".

Valentino retired in January 2008 but, along with Giammetti, has been far from idle. One of the pair's first projects was the founding of the Valentino Garavani virtual museum, a digital archive of his work that can be downloaded and viewed like a virtual museum tour. The pair now spend more time in New York than ever, thanks to Valentino's passion for ballet, and he creates costumes for the New York City Ballet. He also takes on commissions for very special clients, such as actress and friend Anne Hathaway, for whom he designed a wedding dress for her marriage to Adam Shulman in 2012.

"Definitely, we're not retired people," insisted Giammetti about himself and Valentino in an interview for *WWD* in 2012. "Any project that he and I have now is at a different pace. It's not under the stress of 'collection after collection after collection,'... Every project we have now is a bit more relaxed, I would say."

One project that the pair collaborated on in 2012 was the Valentino: Master of Couture exhibition at London's Somerset House. Curated by Patrick Kinmonth and Antonio Monfreda,

e retrospective featured over 130 couture outfits from almost alf a century of Valentino's designs. It included not only outfits ut also personal photographs and clips of films that gave an xtraordinary insight into Valentino's atelier and the complex chniques required to create couture clothes.

Since Valentino's retirement, the company has continued struggle somewhat, requiring it to restructure its debts in 009. Then, in 2012, Valentino S.p.A. was sold once again, is time to the Qatari royal family for €700 million. The ove was supported by Valentino and Giammetti, who told WD: "Sheikha Mozah is our client for a long time. Valentino rsonally did two weddings for the family."

By 2012, with investment secured from Qatar and a steady esign hand under the artistic direction of Maria Grazia hiuri and Pierpaolo Piccioli, Valentino felt confident that e continuation of his label would honoured as he wished, mming up his legacy as: "Precision, personality, courage."

BELOW Valentino and Giancarlo Giammetti continue to socialize globally after their retirement and are pictured here attending the Polo Cup in Greenwich, Connecticut in 2011.

A NEW
CHAPTER

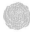

VALENTINO AFTER VALENTINO

In 2008, when Valentino retired, a surprise appointment was announced as his replacement: Italian designer Alessandra Facchinetti, a modern woman less than half Valentino's age. Sceptics immediately predicted a downturn in the quality of design, but Facchinetti's first show impressed the fashion press.

The *Guardian* reported: "Facchinetti silenced critics today with a collection that captured the air of refined seduction that is the essence of Valentino, while bringing the look bang up to date."

Vogue agreed: "Alessandra Facchinetti has big shoes to fill at Valentino. Today she slipped into them with the tact and sensitivity of a young Italian who appreciates the storied heritage of the house, but is quietly resolved to say something to a new generation."

OPPOSITE Maria Grazia Chiuri and Pierpaolo Piccioli acknowledging the applause from the audience after their debut show for Valentino, the Spring/Summer 2009 haute couture collection.

The collection pointed to a way in which a new, younger woman could wear Valentino with as much grace and elegance as the house's traditional older clients. It was full of wearable suits and dresses in a simple colour palette that must surely have won the approval of Valentino himself. Perhaps the only slight disappointments were Facchinetti's interpretations of the trademark Valentino Red chiffon dress. The versions she presented were perfectly accomplished but lacked the red-carpet panache that Valentino himself had always delivered.

But within months, despite the positive start, rumours began to surface that Facchinetti was not up to the job of taking such a powerful old fashion house and modernizing it. Then abruptly, the day after her second collection was shown, Facchinetti was fired. Perhaps the worst part was that Facchinetti did not realize she had been let go until reading it in the press. She issued a statement several hours after the news leaked, expressing her "deep regret" to learn of her dismissal from the press "since the company's top management has not yet seen fit to inform me."

In fact, this hiring and firing of fresh, young designers by old-school fashion houses has become commonplace. At Givenchy, John Galliano lasted just a year before defecting to Dior, his role at Givenchy filled by Alexander McQueen, and at Emanuel Ungaro, a single decade saw three designers – Giambattista Valli, Peter Dundas and Esteban Cortazar – start and quickly leave. Gallingly for Facchinetti, she had experienced the same at Gucci several years earlier, having succeeded Tom Ford in 2004 and then having been quickly fired, again after just two seasons.

Both Giancarlo Giammetti and Valentino expressed their agreement with the decision to fire her. Despite initial enthusiasm from Giammetti for the designer's first collection, he quickly changed his mind at her attempt "to pretend to transform and revolutionise the Valentino style".

For Valentino, it was Facchinetti's failure to respect his

OPPOSITE Chiuri and Piccioli's debut collection played it safe, very much keeping to the traditional style of t house of Valentino by presenting outfit such as this cream pleated silk gown.

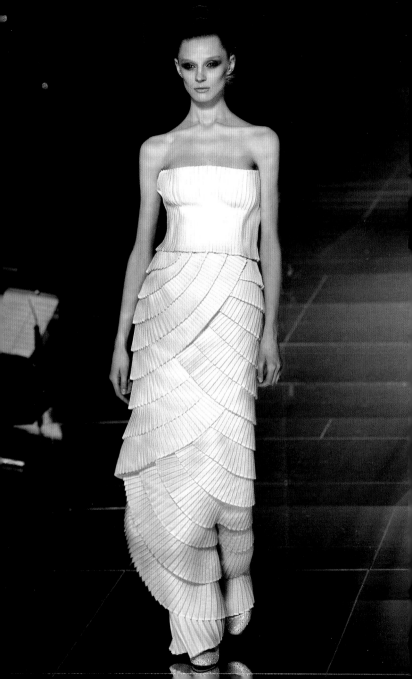

RIGHT For Autumn/
Winter 2009 couture,
a beautifully crafted,
black veiled headdress
complements a silk
chiffon gown with
delicate lace appliqué
over a fitted bustier.

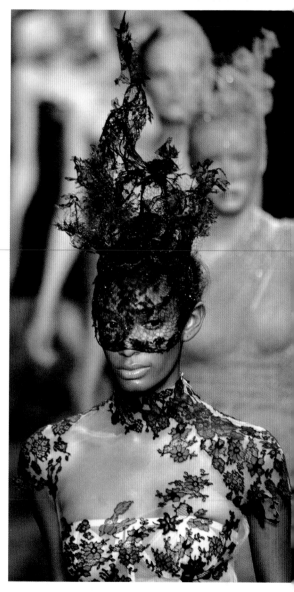

gacy that was unforgivable, especially, he explained, when there is an existing archive with thousands of dresses . . . [to] ke inspiration from to create a Valentino product that is levant today."

Stefano Sassi, chief executive since 2006 and the man idely credited for turning the brand's fortunes around, now announced the promotion of Maria Grazia Chiuri and Pierpaolo ccioli, Valentino's heads of accessories. The appointment as clearly endorsed by Valentino himself; he had personally cruited the pair in 1999 from Fendi to revolutionize his shion house's floundering accessories lines. The relationship, oth between the two designers and the brand's business leaders, ad been a success and the decision to appoint artistic directors om within was a cautious way to protect the house's legacy, pecially after the drama of Facchinetti's abrupt departure.

The debut show for Chiuri and Piccioli was the Spring/ ummer 2009 haute couture collection. There was a great deal ding on their performance, with *Vogue* noting: "the house of alentino needs to regain its sense of equilibrium". But with alentino and his entourage applauding loudly from their front w seats, there was no doubt that the two new designers were etermined to get it right this time.

If anything, the first designs presented by Chiuri and iccioli erred on the safe side. The catwalk was filled with dylike Valentino classics such as cream suits, silk and chiffon resses and crystal-embellished coats with accents of red in the orm of elegantly ruched and draped dresses. Even Valentino's gnature oversized bows and flowers seemed mindfully included, lustrating how respectful the new pair of designers were etermined to be of the grand master. Nevertheless, couture was ever going to be the place where dramatic modernization took lace and Chiuri and Piccioli's first ready-to-wear collection, here change was more likely, was awaited with eagerness.

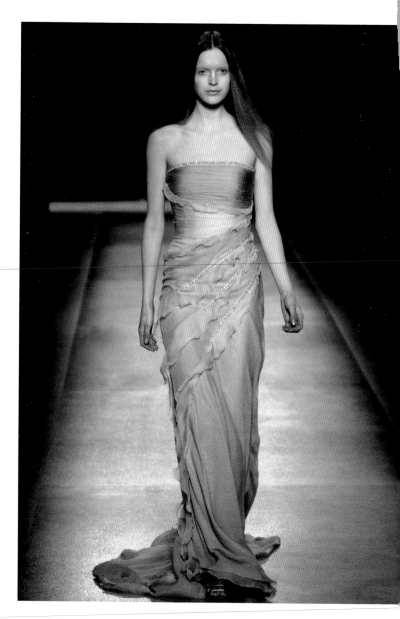

In fact, Autumn/Winter 2009, while still adhering strictly to the Valentino dress codes of old, didn't quite spark a revolution. The design duo's outfits, maintaining the 1960s theme of their couture collection, continued in a sedate, ladylike fashion, the only excitement coming in the form vibrant pops of jewel colours, such as emerald and turquoise. Loyal customers, often ladies of a certain age, must have been happy, but fashion watchers, eager to see how Valentino might be made more relevant to a modern audience under its new leadership, were left disappointed.

Six months later, however, things were looking very different. The Spring/Summer 2010 ready-to-wear collection suddenly had a much younger feel, full of tiny party dresses in draped and ruched organza, chiffon and silk as well as plenty of semi-sheer outfits that would most certainly frighten off the Valentino old guard. Shockingly, there wasn't even a red dress. As Pierpaolo Piccioli explained to *Vogue*: "We wanted to tell a new fairy tale. We're proud of the house heritage, but we wanted to give a personal point of view."

The pair had made the right call. Valentino needed to move forward to stay relevant in the fast-changing world of fashion where other traditional couture houses were shaking things up, and it seemed that Chiuri and Piccioli were the designers to do it. Even their Spring/Summer 2010 couture show, usually a place where tradition held greater sway, led with a futuristic collection of graphic prints and cyber-punk colours that definitely courted a younger clientele. Giancarlo Giammetti was less impressed, condemning it on his Facebook page at the time as a "ridiculous circus".

The contemporary feel continued over their next few collections as the new designers gained confidence. Unsurprisingly, accessories benefited first, being Chiuri and Piccioli's original brief at the fashion house, and the metal-stud motif, especially

OPPOSITE Within a couple of seasons, the Valentino collections started to have a younger, fresher feel. For example, this classic pink silk strapless gown with chiffon ruching and bugle beads is offset by futuristic blue make-up.

the Rockstud spike heel, has gone on to become a cult classic for Valentino. Dresses continued to use generous amounts of fabric drawn into copious drapes and ruffles, but more often than not, these were little party frocks rather than long gowns, offset by harder-edged cropped jackets in glossy leather. The endorsement of Chloë Sevigny, who wore a strapless ruffled lilac Valentino gown to the Golden Globes in 2010, certainly helped the house reach a new crowd.

Much debate ensued as to whether the new popularity of Valentino among bright young things would come at the cost of the brand's loyal, older clientele as well as its traditional reputation. Reviewing the Autumn/Winter 2010 couture show, *Vogue* admired the expert craftsmanship of the truncated, youth-oriented versions of classic Valentino but noted the lack of appeal to the house's former customer: "it was plain to see that Chiuri and Piccioli had done their research on classic couture shapes, however abbreviated they might be here. But that will be scant consolation to mournful clients of the ancien régime."

Young celebrities and socialites were regularly appearing on the front row, however, and a boost in sales reflected the appeal of Maria Grazia Chiuri and Pierpaolo Piccioli's modern expression of house classics. Valentino and Giammetti both expressed their support, applauding enthusiastically at shows and visiting the designers backstage. Giammetti even told *WWD* in 2012: "We think they are great designers. They have been able to bring the Valentino style up to today, in a very modern way but respectful of the past of the house."

With the younger customers reeled in, the most impressive skill exhibited by Chiuri and Piccioli was to incorporate the more traditional elements, using fabrics such as tweed and referencing themes that reached as far back as medieval dress, while still looking contemporary.

"Chiuri and Piccioli's signal achievement has been to turn

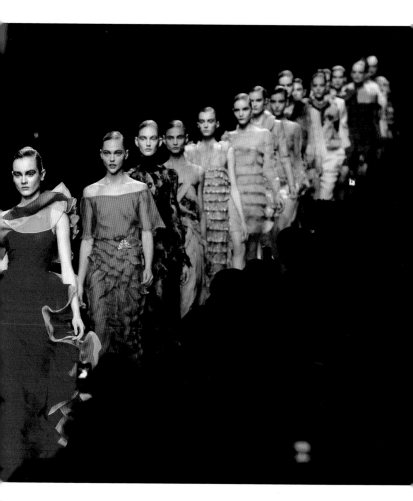

ABOVE By Autumn/Winter 2010, Chiuri and Piccioli
had begun to put their own contemporary mark
on Valentino, while still incorporating the house
trademarks – ruffles, pleats and adornments such as
sequins and bugle beads.

BELOW Despite his
retirement, Valentino
continued to give
his support to Maria
Grazia Chiuri and
Pierpaolo Piccioli. He
is seen here in the
front row of their
Autumn/Winter 2015
show with Giancarlo
Giammetti and
Gwyneth Paltrow.

the old-fashioned into something new and irresistible," read the assessment by *Vogue* in 2011.

As their collections continued, the once stiff, ladylike formality of Valentino clothes continued to soften into a new girlishness. Pretty dresses were crafted from lace and full of the house's favourite florals themes as well as delicate embroidery, but the level of skill and attention to structure meant these were still dresses to fantasize over. Or as Piccioli told *Vogue* in 2011: "Fashion is a dream, and in this moment we need dreams."

While couture and evening wear continued to retain a level of glamour that only comes with a degree of formality, daywear

BELOW Despite his retirement, Valentino continued to give his support to Maria Grazia Chiuri and Pierpaolo Piccioli. He is seen here in the front row of their Autumn/Winter 2015 show with Giancarlo Giammetti and Gwyneth Paltrow.

as a place where Chiuri and Piccioli could experiment with far ss rigid silhouettes. The first inkling came in Autumn/Winter 011, with the appearance of semi-sheer straight dresses and vo-piece outfits composed of ribbed knit sweaters and tiered nee-length skirts, albeit cleverly crafted from lace or even, in ne case, a lattice of lace superimposed onto leather.

The metal stud, the new house signature, appeared scattered in way that crystals might have been in Valentino's day. Chiuri and iccioli's fascination with leather, of the softest and most flattering nd, of course, continued the following year. For Autumn/Winter 012, they presented a series of long and short dresses, skirts, a ouser suit and even a flowing cape made out of glossy hide.

Maria Grazia Chiuri and Pierpaolo Piccioli continued ctfully to challenge the traditional aesthetic of Valentino, ost noticeably in their haute couture shows. For example, in utumn/Winter 2012, the collection had a very different feel, oncentrated on deep sensual blues and dusky purples, dark ousins to the statement red for which the house is so known. ut floral motifs never waned and much use was still made f embroidery and brocade to ensure that the rarefied nature f couture clothes from one of the world's most elite fashion rands was not lost. In fact, the stunning gowns for which the ouse was so famed became only more impressive under the new uard, with elaborately beautiful embellishments and patterns.

Even when the pair went somewhat avant-garde, they were cknowledged for their spirit and creativity. For Autumn/Winter 014 ready-to-wear, they took inspiration from Italian pop art, nding a brightly colourful and graphic collection down the twalk. *Vogue* noted: "When Chiuri and Piccioli came out for eir bow, Valentino Garavani and Giancarlo Giammetti stood applaud and offer kisses of congratulations. The outpouring of fection felt like an appropriate recognition of the duo's talents. hey are this house's beating heart."

OPPOSITE Maria
Grazia Chiuri and
Pierpaolo Piccioli
spent 17 years
together at Valentino,
eight as co-designers-
in-chief. Their final
joint collection,
greeted by rapturous
applause, was the
couture collection for
Autumn/Winter 2016.

Inevitably, things eventually change, and in 2016 it was announced that Chiuri would be leaving the brand to take over from Raf Simons at Dior and that Piccioli would continue as sole design director. Valentino CEO Stefano Sassi paid tribute to the duo's achievements at Valentino in a statement: "Everything achieved in these years would have been impossible without Maria Grazia Chiuri and Pierpaolo Piccioli's talent, determination and vision that together have contributed into making Valentino one of the most successful fashion companies."

Maria Grazia Chiuri and Pierpaolo Piccioli had spent 17 years at Valentino, the last 8 of which saw them assume the role of artistic directors. Adding the time they spent together at Fendi, their working relationship had lasted a quarter of a century; under their leadership, Valentino had been modernized without losing its heritage or identity, as well as reaching a new level of profitability.

Their final joint collection, the couture collection for Autumn/Winter 2016, was a stunning swansong. In acknowledgement of the four centuries since Shakespeare's death, it was an Elizabethan-themed extravaganza, full of ruffled collars, doublets and puffed-sleeve gowns, which paid tribute to the playwright's obsession with Renaissance Italy and the pair's own experience of living and working in Rome.

In a joint statement, Chiuri and Piccioli acknowledged their close working relationship and friendship, and also the importance of allowing one another to grow creatively: "After 2 years of creative partnership and of professional satisfactions we gave ourselves the opportunity of continuing our artistic paths in an individual way with the reciprocal desire of further great achievements."

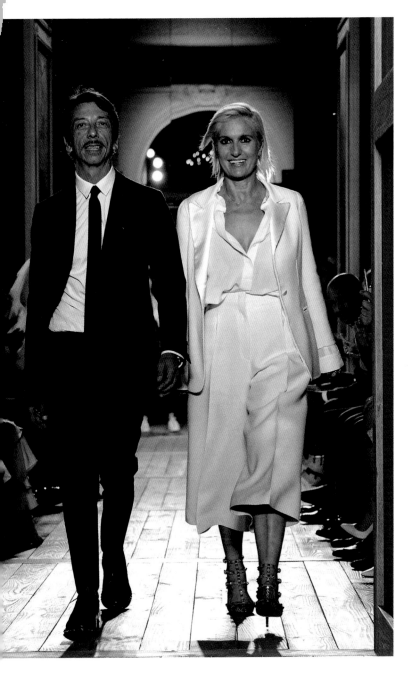

PIERPAOLO PICCIOLI

The huge success that Maria Grazia Chiuri and Pierpaolo Piccioli had achieved at Valentino left many nervous about whether Piccioli could continue to reach the same standards alone. They needn't have worried. His first collection after his long-time collaborator's departure, for Spring/Summer 2017, was a triumph. Inspired by the Hieronymus Bosch triptych *The Garden of Earthly Delights*, it also paid homage to British designer Zandra Rhodes, with whom Piccioli had spent time looking through her archives as he researched his collection. The result was a wonderfully romantic series of bright fuchsia-pink and red outfits, adorned with delicately embroidered birds, flora and fauna. His daywear was also praised for taking pastoral nostalgia and mixing it up with crisp white shirts for a thoroughly modern feel, causing *Vogue* to enthuse: "In short, he aced it, not only meeting expectations but surpassing them too."

Since his debut, Piccioli has gone from strength to strength at Valentino. Stepping into the limelight as sole designer has clearly released new depths of creativity within him. His first couture collection took Greek myths and architecture as its theme, offering long white pleated column dresses and classical draped gowns worth of any goddess. Since then, he has continued to offer collections of clothes researched and curated to a level worthy of an art historian, referencing widely from the Renaissance to Victoriana.

With biannual seasonal presentations spanning the range from the more casual resort collections to the pinnacle of elaborate design represented by haute couture, Piccioli has been unafraid to mix luxe with athleisure, as illustrated in the juxtaposition of tracksuits and mink coats for his resort wear. Haute couture necessarily tips the scale towards elegance and refinement, but even here, bright colours and graphic prints make all his clothes thoroughly modern.

OPPOSITE For Autumn/Winter 201 and in homage to Valentino's love of th voluminous ruffled gown, Pierpaolo Piccioli dressed mod and muse Adut Akec in an extravagant purple creation.

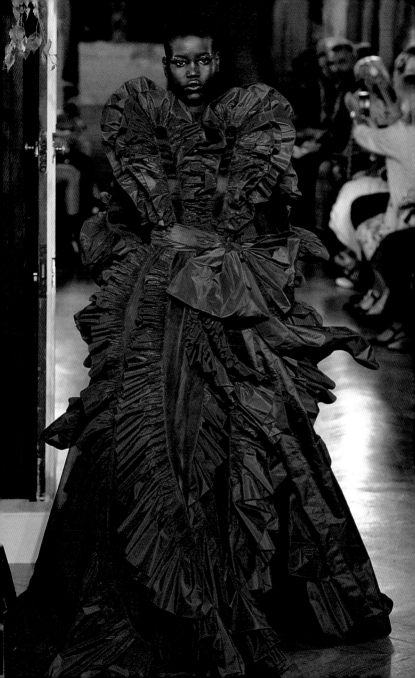

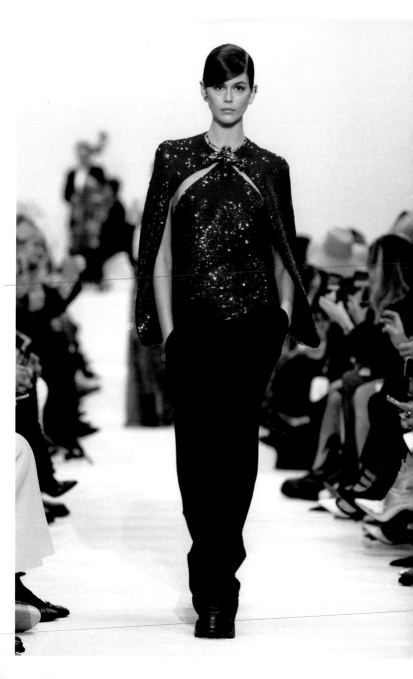

Like Valentino did before him, Piccioli clearly enjoys playing with volume and elaborate adornment within his silhouettes. For Spring/Summer 2018 couture, a voluminous faille coat in ochre yellow was presented complete with a turquoise ostrich feather hat. More feather headgear concoctions followed, some trailing excess strands like a kind of a sea creature. The colours were bright and clashing, full of purple, pink and yellow. It was a more flamboyant glamour than the house of Valentino is known for, but it worked, offering something new and exciting in a fashion world that has too often seen it all before.

Like for many designers, the COVID-19 pandemic and the restrictions imposed on traditional catwalk shows by lockdown conditions have necessitated a new way of conceptualizing fashion. For his Autumn/Winter 2020 couture show, Pierpaolo Piccioli offered a collaboration with photographer and film-maker Nick Knight, entitled Of Grace and Light.

The capsule collection of just 16 looks, all in white, drew obvious comparisons to Valentino's legendary all-white collection of 1968. It was part digital and part physical, staged in Studio 10 of Rome's legendary Cinecittà, yet again reaching far back into Valentino's own early dreams of silver-screen glamour. Knight's film featured trapeze-borne models in gowns that were more sculpture than dress, reaching far beyond the limitations of the female form, giving them surreal, Alice-in-Wonderland proportions. Next, curtains were opened to show the real-life models, balancing on high ladders so that the dresses with their metres of fabric could cascade to the floor. With just a small audience in attendance, it was all live-streamed via Zoom, a magical fantasy and perfect escapism from the dire global situation.

As his journey at Valentino continues, Piccioli has challenged the traditional haute couture system more and more. In an increasingly gender-neutral world, sending male models

OPPOSITE Piccioli has continued the legacy of Valentino's elegant womenswear while still making it feel current – illustrated perfectly by this combination of black tailored trousers and an electric-blue, batwing-sleeved sequinned top, modelled by Kaia Gerber.

BELOW Taking Valentino throughly up to date, Piccioli has juxtaposed athleisure with classic Valentino tailoring over the last few seasons. This brightly printed blue shirt combination for Spring/Summer 2020 menswear has a streetwear feel to it, as does the matching bag.

down a couture catwalk broke one barrier, as did his blending of what might be considered casual athleisure wear with the highly structural and embellished clothes we associate with high fashion. Playing with new shapes and silhouettes takes Valentino into a more modern era, but continues to honour the tradition of the house.

Interviewed by *Vogue* before his Spring/Summer 2021 couture show, Piccioli explained: "My idea is to witness the moment… To me, the essence of couture is the ritual, the process, the care, the humanity. That's what makes couture timeless, special."

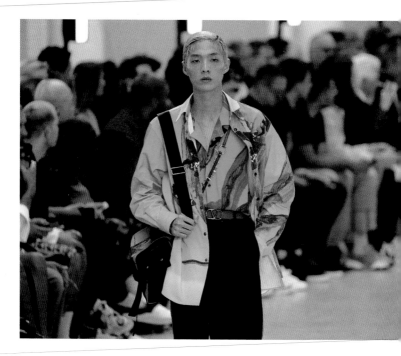

BELOW Taking Valentino throughly up to date, Piccioli has juxtaposed athleisure with classic Valentino tailoring over the last few seasons. This brightly printed blue shirt combination for Spring/Summer 2020 menswear has a streetwear feel to it, as does the matching bag.

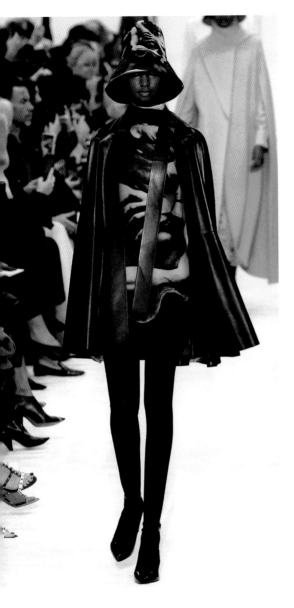

LEFT Leather, a mainstay of the luxury Valentino label since its inception, has been crafted in a very different way by Piccioli, as shown by this black cape over a graphic printed silk tunic with matching hat for Autumn/Winter 2019.

INDEX

CREDITS

The publishers would like to thank the following sources for their kind permission to reproduce the pictures in this book.

Alamy: dpa picture alliance 93; /Alberto Grosescu 94-95; /Reuters/Regis Duvignau 155; /Reuters/Charles Platiau 154

Getty Images: Slim Aarons 115; /Carlo Allegri 48; /Arnal/Picot/Gamma-Rapho 85, 86; /Bassignac/Buu/Gamma-Rapho 120; /Benainous/Rossi/Gamma-Rapho 123; /Dave Benett 25, 108; /Bettmann 19, 34, 63; /Joe Buissink/WireImage 56; /Stephane Cardinale/Corbis 50; /Pascal Chevallier/Gamma-Rapho 116; /Alain Dejean/Sygma 102; /Antonio de Moraes Barros Filho/WireImage 127; /Darren Gerrish/BFC 49; /Gianni Girani/Reporters Associati & Archivi/Mondadori Portfolio 35; /Ron Galella Collection 46, 60, 62, 64, 83; /Gianni Giansanti/Gamma-Rapho 82, 91; /Francois Guillot/AFP 128-129, 136, 139, 144-145; /Frazer Harrison 53; /Rose Hartman 45, 65; /Anthony Harvey 57; /Keystone/Hulton Archive 29; /Patrick Kovarik/AFP 140; /Licio d'Aloisio/Reporters Associati & Archivi/Mondadori Portfolio 24; /Stephen Lovekin/FilmMagic 98; /Thierry Orban 101;

/Franco Origlia 52; /Robin Platzer/Images 71; /Marisa Rastellini/Mondador 9, 70, 111; /Reporters Associati & Archivi/Mondadori Portfolio 26; /Bertrand Rindoff 47, 73, 74; /Rafael Roa/Corbis 6; /Pascal Le Segretain 152; /Daniel Simon/Gamma-Rapho 54, 75, 77, 78, 79, 80-81, 89; /Simon Stevens/Gamma-Rapho 90; /Amy Sussman 55; /Eric Vandeville/Gamma-Rapho 124, 130; /Pierre Vauthey/Sygma/Sygma 87; /Elisabetta Villa 146; /Victor Virgile/Gamma-Rapho 76, 88, 151; /Franco Vitale/Reporters Associati & Archivi/Mondadori Portfolio 12, 22

Shutterstock: Alinari 42; /AP 30; /ArdoPics: 14-15; /Henry Clarke/Condé Nast 32-33, 37, 38-39, 67; /Creative Lab 96; /Jonathon Hadfield 99; /Keith Homan 105; /G Jacopozzi/AP 27; /Duane Michals/Condé Nast 68-69; /NeydtStock 92; /Report 97; /Snap 16-17

Every effort has been made to acknowledge correctly and contact the source and/or copyright holder of each picture and Welbeck Publishing Group apologizes for any unintentional errors or omissions, which will be corrected in future editions of this book.